# Painting More Animal Friends

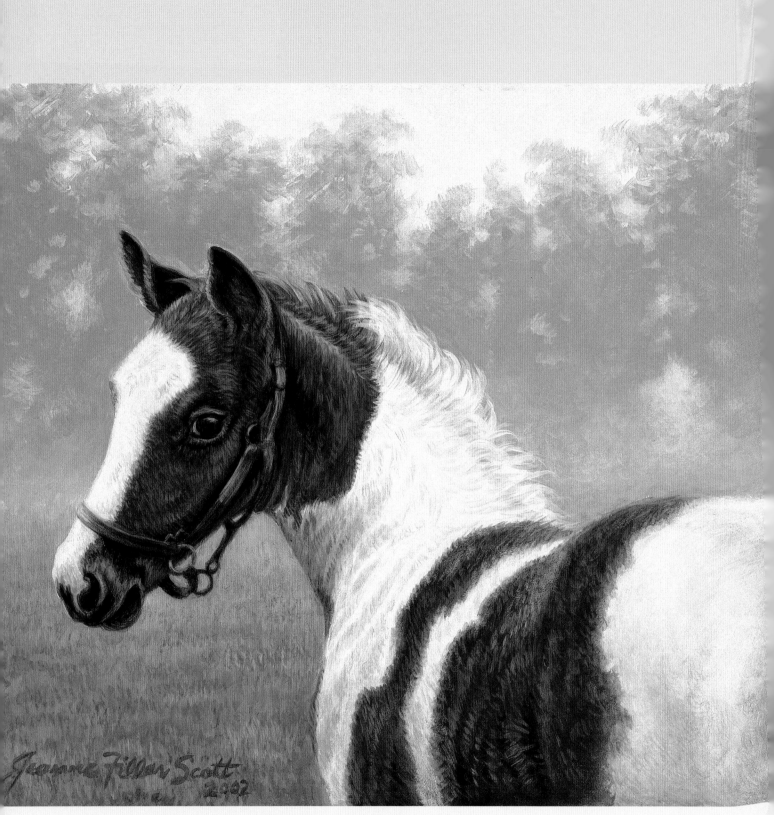

**Young Paint**
Acrylic on Gessobord
8" × 10" (20cm × 25cm)

# Painting More
# Animal Friends

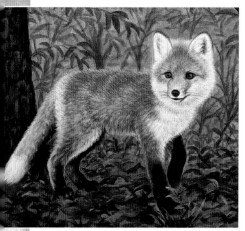
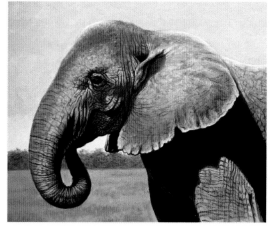
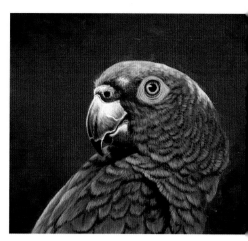

JEANNE FILLER SCOTT

**NORTH LIGHT BOOKS**
CINCINNATI, OHIO
www.artistsnetwork.com

Other fine North Light Books are available from your local bookstore, art supply store or visit our website at www.fwpublications.com.

12  11  10  09  08    5  4  3  2  1

DISTRIBUTED IN CANADA BY FRASER DIRECT
100 Armstrong Avenue
Georgetown, ON, Canada L7G 5S4
Tel: (905) 877-4411

DISTRIBUTED IN THE U.K. AND EUROPE
BY DAVID & CHARLES
Brunel House, Newton Abbot, Devon, TQ12 4PU, England
Tel: (+44) 1626 323200, Fax: (+44) 1626 323319
Email: postmaster@davidandcharles.co.uk

DISTRIBUTED IN AUSTRALIA BY CAPRICORN LINK
P.O. Box 704, S. Windsor NSW, 2756 Australia
Tel: (02) 4577-3555

**Library of Congress Cataloging in Publication Data**
Scott, Jeanne Filler.
    Painting more animal friends / by Jeanne Filler Scott. -- 1st ed.
        p. cm.
    Includes index.
    ISBN 978-1-60061-034-9 (pbk. : alk. paper)
    1. Animals in art--Juvenile literature.   2. Acrylic painting--Technique. I. Title.
ND1380.S378 2008
751.4'26--dc22                              2007051917

Edited by Mary Burzlaff and Sarah Laichas
Cover design by Jennifer Hoffman
Interior design by Jessica Schultz
Production coordinated by Matt Wagner

f+w
F+W PUBLICATIONS, INC.

## METRIC CONVERSION CHART

| To convert | to | multiply by |
| --- | --- | --- |
| Inches | Centimeters | 2.54 |
| Centimeters | Inches | 0.4 |
| Feet | Centimeters | 30.5 |
| Centimeters | Feet | 0.03 |
| Yards | Meters | 0.9 |
| Meters | Yards | 1.1 |

## ACKNOWLEDGMENTS

I would like to thank all of the people and organizations who helped me in my quest for good animal references. These include Black Beauty Ranch (operated by The Fund for Animals) for the elephant; the Louisville Zoo for the scarlet ibis and the zebra foal; the Cincinnati Zoo with its leash-trained big cats for the white tiger cub and for the giraffe; Pennyroyal Small and Exotic Animal Hospital, Lexington, Kentucky, for the raccoon baby; Wolf Park, Battle Ground, Indiana, for the wolf puppy and bison calf; the Caldwell Zoo, Tyler, Texas, for the hyacinth macaws; the Arizona-Sonora Desert Museum, Tucson, Arizona, for the black bear; Waterford Farm, Midway, Kentucky, (where I saw the white-tailed deer); Bedford Farm, Paris, Kentucky, for the paint foal; The Primate Rescue Center, Wilmore, Kentucky, for the peacock; Gwen McNew, wildlife rehabilitator, for the baby cottontail rabbit; and Donna Akins, wildlife rehabilitator, for the fox cub.

    I would also like to thank my editors, Mary Burzlaff and Sarah Laichas, for their patience, encouragement and good suggestions.

## DEDICATION

I would like to dedicate this book to all people who have compassion for and who lend a helping hand to animals: the people who take in homeless dogs and cats, the wildlife rehabilitators, the Humane Society volunteers, those working to save endangered species and their habitats, members of organizations trying to stop and prevent animal neglect and cruelty, the person who stops his or her car to move a turtle out of the road, to name a few. To quote the song, "Bless the Beasts and the Children," "Bless the beasts and the children / For in this world they have no voice / They have no choice." The world would be a better place if more of us reached out to help those without a voice or a choice.

# ABOUT THE AUTHOR

The animal art of Jeanne Filler Scott links painting techniques of the Old Masters with today's knowledge and appreciation of the natural world. An interviewer once wrote that the animals in Jeanne's paintings have the "spark of life." Looking into the eyes of one of her animals, one feels the animal looking back. "I paint with the understanding that each animal is unique," Jeanne says. "The animal may represent the entire species as an ideal, but on a deeper level, the animal before me is an individual. I try to do justice to my subjects and give their images the vitality and character they deserve."

Jeanne's work has appeared in many exhibitions, including the Society of Animal Artists, Southeastern Wildlife Exposition, National Wildlife Art Show, MasterWorks in Miniature, NatureWorks, Nature Interpreted (Cincinnati Zoo), the American Academy of Equine Art, the Kentucky Horse Park and Brookfield Zoo. Several of her paintings are published as limited edition prints, a number of which are sold out.

Jeanne's paintings are published on greeting cards by Leanin' Tree, and she has been featured on the covers and in articles of magazines such as *Equine Images, Wildlife Art, InformArt* and *The Chronicle of the Horse*. She is the author of the book *Wildlife Painting Basics: Small Animals* (North Light Books, 2002) and *Painting Animal Friends* (North Light Books, 2005.) In addition, her work has been included in the books *The Best of Wildlife Art* (North Light Books, 1997), *Keys to Painting Fur & Feathers* (North Light Books, 1999) and *The Day of the Dinosaur* (Bison Books, 1978), which was later re-released as *The Natural History of the Dinosaur*.

She is a member of the Society of Animal Artists and Artists for Conservation (formerly known as the Worldwide Nature Artists Group).

Jeanne and her family live on a farm in Washington County, Kentucky, surrounded by woods, fields and the Beech Fork River. Many kinds of wild creatures inhabit the

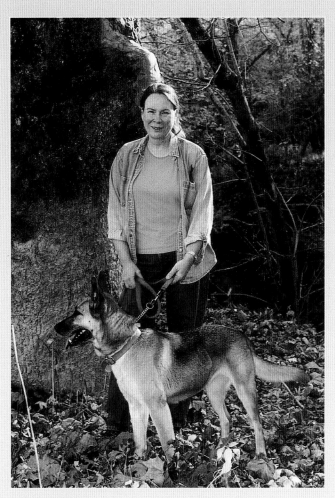

**Jeanne and Sasha**
Photo by Tim Scott
Jeanne rescued Sasha, who had been abandoned along a roadside in Kaufman County, Texas, in 1998.

farm, including opossums, deer, turkeys, raccoons, foxes, coyotes, box turtles, squirrels, woodchucks and rabbits. Jeanne, her husband, Tim, and son, Nathaniel, often rescue animals in need. Their animal family includes twelve dogs, twelve cats, three chickens, six horses, several cows, an opossum and a tree frog.

See more of Jeanne's work on her website at www. jfsstudio.com and at www.natureartists.com.

# TABLE OF CONTENTS

**INTRODUCTION**     **8**

PART ONE

**WOODLAND ANIMALS**     **20**

Columbian Ground Squirrel     22

Cottontail Rabbit     28

White-Tailed Deer     32

Chipmunk     36

Black Bear     40

Box Turtle     44

PART TWO

**BABY ANIMALS**     **50**

Raccoon Baby     52

Opossum Baby     58

Wolf Pup     62

Paint Foal     66

Bison Calf     70

Fox Cub     74

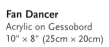

**Fan Dancer**
Acrylic on Gessobord
10" × 8" (25cm × 20cm)

**Feather Bed**
Acrylic on Masonite
8" × 10" (20cm × 25cm)

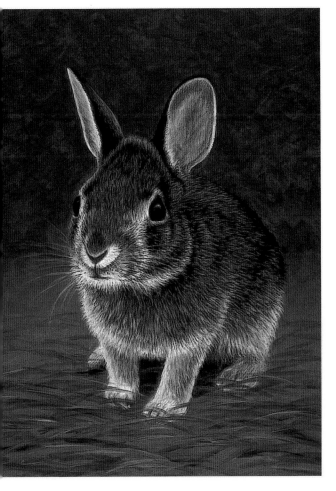

PART THREE

# EXOTIC ANIMALS     80

    Elephant     82
    Giraffe     88
    White Tiger Cub     92
    Zebra Foal     96
    Ring-Tailed Lemur Baby     100

PART FOUR

# BIRDS     106

    Peacock     108
    Parrot     114
    Scarlet Ibis     118
    Hyacinth Macaws     122

# CONCLUSION & INDEX     126

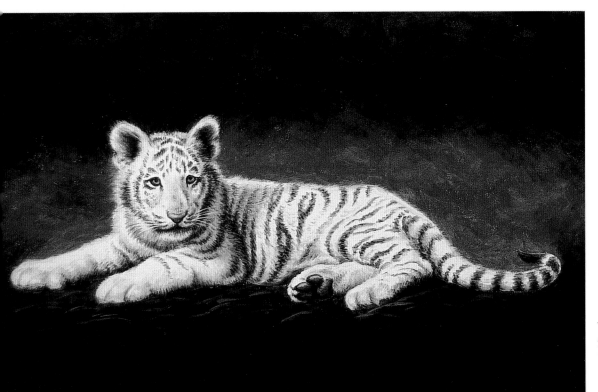

**Tiger Child**
Acrylic on Gessobord
7½" × 12" (19cm × 30cm)

# INTRODUCTION

*Painting More Animal Friends* is a companion to my previous book, *Painting Animal Friends*. While the first book dealt with painting domesticated animals, most of the subjects in this book are wild animals. For the most part, I've chosen those that are familiar to people, but I have included some interesting and attractive animals you might not be as familiar with, such as the ring-tailed lemur and the scarlet ibis. I've also included well-known creatures like opossums and box turtles that aren't frequently included in books on how to paint animals.

You will learn how to paint realistic fur for tiger cubs and raccoons, as well as how to paint the short-haired coats of giraffes and foals, the wrinkled skin of elephants, the patterned coats of zebras and the feathers of birds, from parrots to peacocks. I've included instructions on painting eyes, ears, feet, whiskers and other details, plus techniques you can use to integrate the animals into their background. You will learn how to paint animals not only to look realistic but to look as if they are alive and have a sparkle in their eye.

Template drawings are included, both to demonstrate what essential lines to include in a sketch and to use as a basis for your painting if you so choose. I encourage you to observe and to draw animals, both from photos and from life, so you will learn about their individual anatomy and characteristics.

Most importantly, enjoy drawing and painting animals!

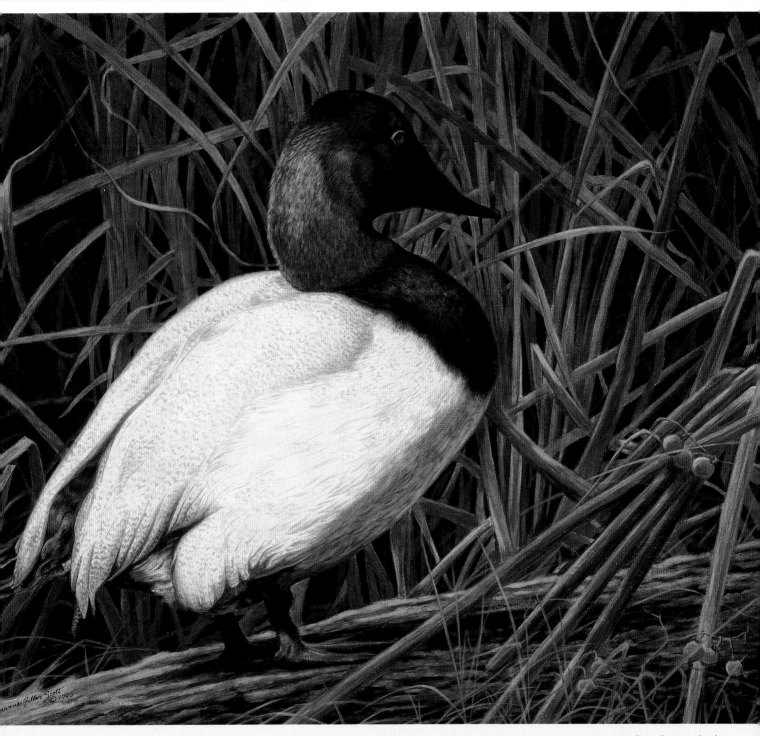

**Cattails and Canvasback**
Acrylic on 100% rag board
13" × 17" (33cm × 43cm)

# Materials Needed

All the paintings in this book are rendered in acrylic. The following pages contain information on materials and tips for working with acrylic.

## BRUSHES

The brushes used in this book, which are available through Dick Blick Art Materials, are: no. 3 round, no. 10 round, no. 2 bright, no. 4 bright, no. 6 bright, no. 8 bright, no. 10 bright and no. 12 bright. The rounds are Dick Blick wonder white 2024 series brushes. The brights are called Blick academic synthetic brights and can be purchased in a set, which also includes a larger brush that was not used in this book.

The numbers used to designate the sizes of brushes vary widely from one manufacturer to another, so that, for example, a no. 4 of one brand can be much larger or smaller than a no. 4 of a different brand.

I used one brush that was not made by Dick Blick, because I could not locate a brush in the size that I needed. The brush I call a no. 10 bright in this book (since it is between a Dick Blick no. 8 and no. 12 in size) is actually an Arttec white nylon 525B bright.

Rounds are best for detail, as they come to a fine point. Brights are used for broader areas such as grass and skies as well as chunkier details such as a woolly bison calf coat.

It is best to have two or three of the more frequently used brushes, such as nos. 3 and 10 rounds, and nos. 4, 6, 8 and 12 brights. As you'll see in the demos, often you will need two or three of the same size brush, each for a different color, so you can use them alternately while blending.

## SURFACE

The painting surface for the demonstrations in this book is Gessobord (a product of Ampersand Art Supply, Austin, Texas), a preprimed Masonite panel with a nice texture for realistic painting. It comes in a variety of sizes. Most of the demos in this book were done on 8" × 10" (20cm × 25cm) panels, while a few were 9" × 12" (23cm × 30cm). For a couple of them—the cow's head and the baby chicks—I used only part of a panel.

## JAR OF WATER

Water is the only medium I use to thin my acrylic paints. It is important not to let your water get too murky with paint.

## PAPER TOWELS

Paper towels are used for blotting excess paint or water from your brush. Keep a folded paper towel by your palette and a crumpled one in your lap or hand.

## SPRAY BOTTLE

Keep your paint palette from drying out with a spritz or two or water from a handy spray bottle.

## NO. 2 PENCIL AND KNEADED ERASER

You'll need a pencil and an eraser for drawing or tracing the image onto your panel. The kneaded eraser is good for making corrections, and for lightening pencil lines on your panel so they won't show through the paint.

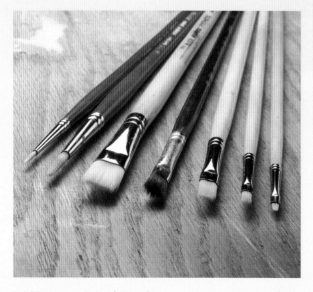

**Brushes**
This is a good selection of brushes for painting animals and backgrounds. Here, from left to right, are a no. 3 round, no. 10 round, no. 12 bright, no. 10 bright, no. 6 bright, no. 4 bright and no. 2 bright.

## TRACING PAPER

Tracing paper is used to trace your sketch or the template drawing provided with each demo. After tracing your sketch, you can transfer it to your Gessobord panel. The advantage of doing the sketch on a separate piece of paper, and not directly onto the panel, is that you have much more control over the size and the placement of your subject. This will usually result in a better painting.

## PALETTE

The Masterson Sta-Wet Palette keeps your paints from drying out for days or even weeks. The 12" × 16" (30cm × 41cm) size is best, as it gives you plenty of room to mix colors. There is nothing more frustrating than to run out of room on your palette in the middle of a painting! The palette consists of a plastic box that is 1¾" (4cm) deep, and comes with a sponge insert that fills the bottom of the box when wet. A special disposable paper called acrylic film, which is discarded after it is used up, sits on top of the sponge insert. The box has an airtight lid.

The directions that come with this palette tell you to saturate the sponge with water and explicitly instruct not to wring out the sponge. However, I find that if I don't press out some of the water, my paints turn into a soupy mess after a short time. If the paints start to dry after a few days, spray them lightly with water from a spray bottle.

## PALETTE KNIFE

You'll need a palette knife for mixing colors. A tapered steel knife works best, and the trowel type (rather than straight), with a handle that is lifted above the blade, is the easiest to use. Be sure to clean your palette knife between colors. Wiping it on a paper towel is usually sufficient, but you'll have to rinse it in your water jar occasionally.

## WAX PAPER

There will be times when you need a color to be thicker than it is when on the surface of the Sta-Wet Palette, as the palette always adds a small amount of water to the paint. For example, when painting a highlight that you really want to stand out, you want very little water mixed with the paint. It's useful to keep wax paper on hand so you can transfer some color to it if necessary. The paint will dry up quickly, but it will be a thicker consistency.

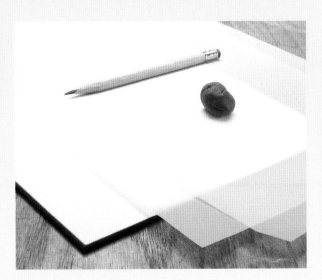

**Drawing Supplies**
With a no. 2 pencil, draw your image onto the tracing paper, using a kneaded eraser for corrections. Transfer the sketch to the panel with homemade carbon paper (see page 13).

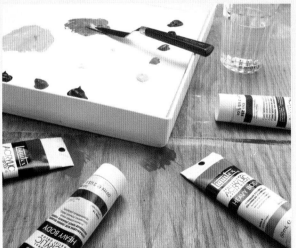

**Palette**
The Masterson Sta-Wet Palette keeps your paints from drying out as you work. The tapered trowel-type palette knife is used for mixing colors.

Burnt Sienna

Burnt Umber

Cadmium Orange

Cadmium Red Medium

Cerulean Blue

Hooker's Green Permanent

Naples Yellow

Raw Sienna

Red Oxide

Scarlet Red

Titanium White

Ultramarine Blue

Yellow Light Hansa

# MIXING COLORS

The demos in this book were painted with Liquitex acrylic paints that come in tubes. I tried another brand recently, and while the paint itself was fine, the cap on the tube was so small that I couldn't close it. I frequently found that the paint had dried out at the opening, which made it difficult to squeeze anything out. I've since switched back to Liquitex.

The colors used in the different demos vary with the subject, some requiring more colors than others. A complete list of the colors used in this book is included below.

## MIXTURES

Most of the colors you use will be a mixture of two or more paints. If you use colors straight from the tube, the result will probably be garish and unrealistic.

Be sure to mix a large quantity of each color so that you have enough to finish the painting, as well. This is easier than mixing the same color again. Save all of your color mixtures until you have completed the painting. You never know when you may need the color again to re-establish a detail, for example. You can also frequently use a previously mixed color as the basis for a new color. Simply add another color or two to a portion of a mixture you've already created.

## Useful Acrylic Mixtures

Here are some useful color mixtures:

**Warm black.** Mix Burnt Umber and Ultramarine Blue to paint an animal's coat. This black looks more natural than black from a tube.

**Warm white.** For painting animal fur, clouds or wildflowers, mix Titanium White and a touch of Yellow Light Hansa or Naples Yellow.

**Basic green.** Mix a basic green for grass and trees with either Viridian (a cool green useful for evergreens and water reflections) or Hooker's Green Permanent (a warmer green useful for sunlit fields). Add small amounts of Cadmium Orange and Burnt Umber to tone down the green. For darker shadows, mix in some Ultramarine Blue and more Burnt Umber. For highlight colors, add some Titanium White and Naples Yellow, Titanium White or Yellow Light Hansa.

**Natural pink.** For the noses and inside the ears of white-furred animals, mix Cadmium Red Medium, Naples Yellow and a touch of Raw Sienna.

**Basic grass.** Mix a basic grass color with Hooker's Green Permanent, Titanium White, Naples Yellow and a small amount of Cadmium Orange.

**Bluish green.** For distant trees, mix Titanium White, Hooker's Green Permanent, Ultramarine Blue and a bit of both Cadmium Orange and Raw Sienna.

**Blue sky.** Mix a blue sky color with Titanium White, Ultramarine Blue and a touch of Naples Yellow.

You can lighten or darken any of these colors to suit your painting. Experiment with these mixtures.

black

warm white with Cadmium Yellow Light

warm white with Yellow Oxide

basic green with Viridian

basic green with Permanent Hooker's Green

natural pink

basic grass color

bluish green

blue sky color

## TIP

When you mix a color on your palette, you can't be certain how it will look in the painting until you see it next to the colors already on your panel. Test the mixture by placing a small dab on the area to be painted. You can then modify the color so it will be the best for your painting.

# BEGINNING A PAINTING

Template drawings of each animal are provided with each demonstration in this book. You can use these templates or create your own sketches.

## TRANSFERRING YOUR SKETCH

Whether you use the template or a sketch of your own, use a piece of tracing paper and a fine point black marker to trace the image.

You can enlarge or reduce the size of the image to fit your panel with a copy machine or an opaque projector. If you use a photocopy, blacken the back of the copy with a no. 2 pencil, then tape they copy to your panel and trace the image with a pencil. You'll need to bear down with a fair amount of pressure, but this should result in transferring the graphite from the back of your photocopy onto the panel. Lift the tracing or copy paper occasionally to make sure you are pressing down hard enough and are getting the complete image. If your tracing comes out too dark (so that it will show through the paint) use a kneaded eraser to lighten it.

If you use an opaque projector, you can trace the sketch directly onto the panel from the projected image. This is a little more difficult than you might think, since you have to stand to one side so you don't block the light from the projector.

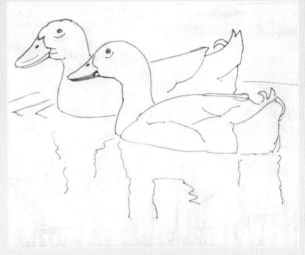

**The Sketch**
With homemade carbon paper positioned underneath, the sketch is easily traced onto the panel.

**TIP**

Make your own carbon paper by blackening the back of a blank piece of tracing paper with a no. 2 pencil. You can use this homemade carbon paper over and over.

## DOING AN UNDERPAINTING

Once you have a pencil sketch on your panel, you are ready to do the underpainting. Neutral colors such as Burnt Umber or Payne's Gray, thinned with water, are good for this. As a rule of thumb, use Burnt Umber for brown or warm-colored animals—such as a chestnut horse—and Payne's Gray for gray, black, or white animals, such as a Dalmatian.

Squeeze out some of the underpainting color onto your palette, then mix it with a small amount of the water on the palette's surface. You want the paint to be thin but not too runny. Begin to paint, not worrying much about detail at this point. Just establish the main lines and the lights and darks. The purpose of the underpainting is to give you a rough guide to go by when you begin painting in full color.

## GENERAL STEPS FOR COMPLETING THE PAINTING

Once you have finished the underpainting, you are ready to apply the darkest value colors. This is followed by the middle value and then the lightest value colors. You will start with a small amount of detail, building upon this and adding more detail with each step. Doing a realistic painting is basically a process of refining as you go along and building upon what you've already done. In the final step, you will paint the finishing details.

## THICKNESS OF THE PAINT

When painting with acrylics, use just enough water so that the paint flows easily. You will usually need to apply two to three layers to cover an area adequately. Since the paint dries so quickly, this is easily accomplished. In general, shadows are painted fairly thin, while highlighted areas benefit from a little more thickness, which makes them stand out.

# Types of Brushstrokes

Learning to handle your brush is crucial in depicting the texture of fur, clouds, grass and feathers. There are several types of strokes you should be familiar with when painting the natural world.

## Dabbing Vertical Strokes

These strokes are done quickly, in a vertical motion, with either a round or a flat brush. They are good for painting the texture of grass in a field.

## Smooth Flowing Strokes

These strokes are good for long hair, such as a horse's mane or a long-haired cat's tail. Use a round brush with enough water so the paint flows, and make the strokes flowing and slightly wavy.

## Dabbing Semicircular Strokes

These are done fairly quickly, in a semi-circular movement, with a flat brush such as a shader. These strokes are good for skies, portrait backgrounds or other large areas that need to look fairly smooth, such as a wall or floor.

## Small Parallel Strokes

Use this kind of stroke to paint detail, such as short animal fur or bird feathers, using the tip of your round. Be sure to paint in the direction the hair or feathers grow on the animal.

## Glazing

A glaze or wash is used to modify an existing color by painting over it with a different color thinned with water, so that the original color shows through. This creates a new color that you couldn't have achieved any other way. Dip your brush in water, then swish it around in a small amount of the glazing color. Blot briefly on a paper towel so you have a controllable amount of the glaze on your brush, then paint the color smoothly over the original color. In this example, a glaze of Burnt Sienna was painted over a portion of the log to show how the glaze warms up the colors.

## Drybrush or Scumbling

This is when you modify a color you've already painted by painting over it with another color in an opaque fashion, so that the first color shows through. Dip a moist, not wet, brush into the paint, then rub it lightly on a paper towel so that there is just enough paint to create a broken, uneven effect when you paint over the original color. Repeat as necessary.

## Smooth Horizontal or Vertical Strokes

These strokes are good for man-made objects and water reflections. Using enough water so the paint flows, but is not runny, move your round brush evenly across the surface of the panel.

# CREATING BACKGROUNDS

The background is frequently as important as the animal itself. Don't forget to include some of your subject's natural setting.

Work on the background and the subject simultaneously. This will make it much easier to integrate the animal with its surroundings. In a painting where the subject is defined by the background colors, such as white ducks against dark water, you will need to paint the background color earlier in the process.

There are two types of backgrounds used in the demos in this book: portrait and full (landscape) backgrounds.

## PORTRAIT BACKGROUND

A portrait background usually consists of a basic color that sets off the main subject. There is often some variation, such as darker versions of the color in some areas that are blended into the main color. Another variation can be achieved by drybrushing another color over the original color. If the entire body of the animal is shown, it's a good idea to paint a shadow or a few sprigs of grass around the subject. A portrait background is often used when a detailed background would distract from the subject, such as when painting a head portrait.

## LANDSCAPE BACKGROUND

Landscape backgrounds are more of a challenge, but they can add a lot to a painting. The landscape does not need to have much detail to be effective. In fact, having too much detail in the background will distract the viewer from the focal point. Paint just enough detail to make the background look realistic.

### Close-up Grass
Paint close-up grass with a dark green shadow color and a lighter, basic grass color. Use round brushes to paint flowing, slightly curving strokes that taper at the ends and go in various directions. Overlap the greens and add some brown detail to integrate the animal and/or add realism, since most grass does not look as perfect as a golf course!

### Broad Areas of Grass
Paint broad areas of grass with a combination of vertical and horizontal brushstrokes, with mostly vertical strokes in the foreground, transitioning to more horizontal strokes farther back. Make the strokes smaller as they recede into the landscape.

### Clouds
Paint clouds in the sky with a warm white mixture. Use a flat brush and light, feathery dabbing strokes to paint the clouds right over the blue sky. Use a separate brush and the blue sky color to blend the undersides of the clouds with the sky.

### Skies
Paint skies with dabbing, semicircular strokes and a flat brush, such as a no. 10 shader. Make the sky lighter at the horizon by adding more Titanium White to a portion of the basic sky color, blending where the two colors meet.

### Painting Trees
Paint trees with a basic green color mixture, using dabbing strokes and a flat brush. With a lighter green and a round brush, paint some detail to suggest clumps of leaves.

# FINDING ANIMAL SUBJECTS

Here are some places to find wild animal subjects:

## ZOOS

Zoos are great places to sketch animals from life and gather great reference photos. Some modern zoos have the animals in naturalistic settings, which are not only better for the animals but also for the artist because it helps you place the animals in a more natural environment in your painting. If you tell the zoo employees that you are an artist, they will often be glad to assist, possibly even giving you a private showing of the animal you're interested in.

## PARKS

Parks and places where animals such as squirrels are fed and protected (and have lost much of their fear of people) can be good places to see wild animals up close. National parks such as Yellowstone National Park in Wyoming and Banff National Park in Canada, where hunting is not allowed, provide wonderful close-up wildlife viewing of animals such as deer, bighorn sheep, moose, bison, mountain goats, squirrels and many kinds of birds.

## WILDLIFE REHABILITATORS

Wildlife rehabilitators take in injured or orphaned wild animals and try to nurse them back to health so that they can be returned to the wild. If the animal cannot be released, they often provide it a home. I have found these people to be very friendly and helpful. They don't get the credit they deserve for all the good work they do, and they are usually happy to share the animals with people who are interested in them.

## VETERINARY CLINICS

Veterinary clinics that take in wildlife can be approached for references. Some veterinarians volunteer their services to help wild animals in need, giving them emergency care and then turning them over to wildlife rehabilitators.

## HIKING TRIPS

While hiking in the country or woods, always carry your camera and sketchbook in case an opportunity arises. You never know when you might happen upon an animal that is as surprised as you are at the encounter! You can also gather references for backgrounds—from wide-angle views of fields and forest clearings to small details such as ferns and toadstools.

Domestic animals are easy to find. The following are some common sources:

## PET OWNERS

If you want to paint a Siamese cat, for example, ask your friends if they know anyone who has one, or call your local Humane Society or veterinary clinic for a referral. Most pet owners are proud of their animals and will gladly allow you to photograph them.

## STATE AND COUNTY FAIRS

County fairs are often a good place to see a variety of domestic animals such as rabbits, chickens and horses. You can sketch and photograph them at your leisure. If you talk to the people who raise the animals, you have a good chance of being invited to their homes to see the animals in a quieter setting.

## FARMS

Horses, cattle, goats, chickens, llamas and other domestic animals can be found on farms. Take a drive through the country and pull to the side of the road to photograph or sketch animals. Always get the owner's permission before entering fields with animals.

Other places to see animals include horse shows, racetracks, dog shows, cat shows, herding dog trials, aquariums and pet shops. The opportunities for good reference gathering are out there—you just have to take advantage of them!

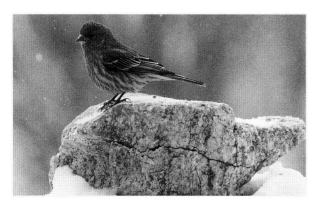

## Painting a Purple Finch

Last winter, we had many different kinds of birds at our feeders, including purple finches. Using a zoom lens, I took this photo through the glass doors that look out onto our deck. The rock we had put on the railing as a decoration made a perfect setting for the finch, with the falling snow in the background. In order to make sure the details of the bird's feathers were correct, I referred to several bird books. I often photograph the birds our feeders attract and have accumulated a large file of photos of many different species.

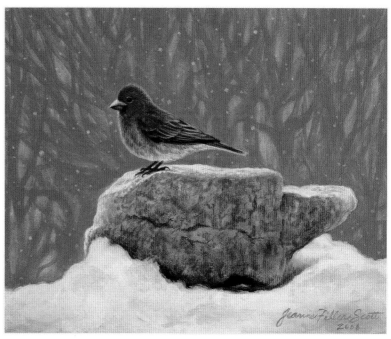

**Purple Finch**
Acrylic on Gessobord
8" × 10" (20cm × 25cm)

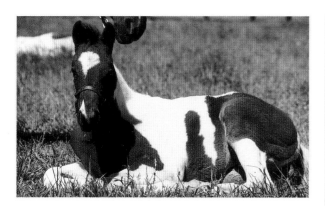

## Painting a Foal

I photographed this reclining paint foal at Bedford Farm in Paris, Kentucky. I had obtained permission from the owner of the farm to spend a couple of hours that morning sketching and photographing in a field with a large number of mares and foals. (Incidentally, this is the same foal portrayed in the Paint Foal demo that begins on page 66.)

There are many ways of gathering references for your artwork. The artist who portrays animals should become as familiar as possible with her subjects.

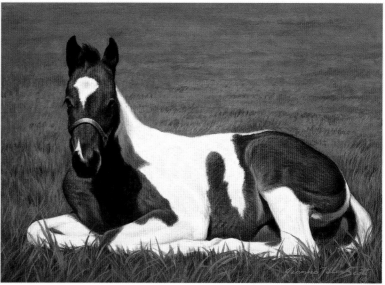

**Color Foal**
Acrylic on Masonite
10" × 14" (25cm × 36cm)

# GATHERING REFERENCES

There are numerous ways to collect your references, but photography and sketching are probably the most common.

## PHOTOGRAPHY

If you are serious about being an artist who paints animals in a realistic, detailed style, photography is an important tool. Since animals move constantly, getting good photos is a challenge. While you can capture only a few lines in a sketch, photographs can preserve a moment in great detail. This gives you a lot more information to work from and more flexibility as an artist.

## CAMERA EQUIPMENT YOU'LL NEED

For basic photography, you'll need a 35mm camera with a normal lens and a telephoto zoom lens. The zoom lens is the most important because it allows you to take close-ups of distant animals. The zoom feature allows you to choose how you want to frame your subject. Even tame, domestic animals can be quite uncooperative about staying close by when you want to photograph them! The normal lens is good for photographing animals that you can get very close to, as well as for taking background photos.

I generally use ASA 400 print film, as this film speed allows you to take photographs in fairly low light conditions. Also, a telephoto lens needs more light to operate, so the 400 speed gives you more latitude. For sunny days, ASA 200 film is good.

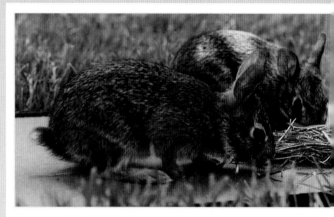

### Photographing Baby Bunnies

These orphaned baby bunnies were being raised by a wildlife rehabilitator. We put them in an aquarium with a lid so that there would be no danger of them escaping while I photographed them.

Make sure any camera you purchase has a motor drive (most do) so that you don't need to advance the film after each shot. If you're shopping for a camera, also consider purchasing a polarizing filter. These fit over the lens to cut down on haze and reflections. I recently started to use a digital camera, too. They are great for taking animal and background photos, and you can take hundreds of photos without having to change film.

## TIPS FOR PHOTOGRAPHING ANIMALS

There is more to photographing animals than simply pointing the camera and pressing the shutter release. Here are some tips:

Get down to the animal's level. Inexperienced photographers often take photos of animals while looking down at them. In most cases, it is better to look at the animal straight on. Sometimes this means you will have to spend a lot of time in an uncomfortable position, crouching or even lying on the ground to photograph smaller animals, but the results are worth it!

Take several rolls of film. The more pictures you take, the greater the chance that you will get that one winning pose that is the basis for a great painting.

Take some close-ups of the animals' features. Photos of eyes, noses and feet. can be extremely helpful when you are working on a painting and the animal is no longer in front of you. Often, the smaller details don't show up well in photos of the entire animal.

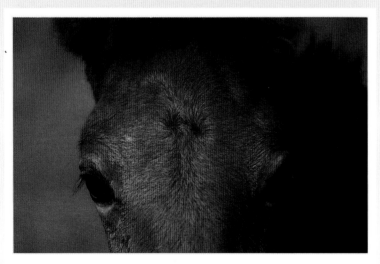

### Taking Close-ups

Take close-up photos of features such as eyes, noses and feet. You will find these to be very valuable later when you are painting in your studio.

Have someone with you for assistance. Often, my husband or my son accompanies me to a photo session. Since they are very experienced with animals, they are real assets. One of the most common problems I have in photographing friendly animals like horses and dogs is that they insist on walking right up to my camera and sniffing the lens! Another person can distract the animal so it will look in another direction rather than right at the photographer.

Make sounds or motions that attract the animal's attention. When I am photographing a dog that looks bored and refuses to put its ears up, I often imitate a cat's meow. This usually causes the dog to prick its ears and cock its head. But some animals just aren't that easily impressed! Sometimes, tossing a small twig or a handful of grass will cause an animal to momentarily look alert.

## TAKING BACKGROUND PHOTOS

In the excitement of photographing the animal, don't forget to photograph the animal's environment if the location is appropriate for a painting. Later on, when you are in your studio working on a painting, you'll be glad you stopped to take a few photos of the background. Also, take close-up photos of elements you might like to include, such as wildflowers, grass or rocks.

You can combine elements from different photos for use in a painting. When using more than one photograph—and when you have a strong light source in your main reference photo—be sure that you paint the background so that all light is coming from the same direction. If all of your photos were taken on a bright overcast day (which is the lighting preferred by many photographers), you don't have to worry about the light source.

## FILING YOUR PHOTOS

It is important to keep your photos in files so that you can find them when you need them. The more specific you make your files, the more useful they will be to you. For example, I have hundreds of photos of horses. Some of my file headings are: Foals, Standing; Foals, Heads; Mares and Foals, Paint; Mares and Foals, Thoroughbred, Grazing.

## SKETCHING

Sketching is a great way to observe animals and have fun at the same time. While you'll discover that animals seldom hold a pose for more than a few moments or seconds, even while they are at rest, you'll learn a lot about their anatomies and their characters. Always carry your sketchbook so you can take advantage of opportunities—you never know when you might see an interesting animal, tree or other natural object. You'll enjoy looking at your sketchbooks later to see what you have captured and to remember the experience.

## BOOKS

Well-illustrated books about animals are a good source of information. I have a large collection of animal books that I refer to on a regular basis—animal encyclopedias, nature field guides and books on animals in art. I've purchased many of these books at used bookstores and library book sales, where you can buy books for a fraction of what they cost new. Children's books usually have good pictures, and you can find books that specialize in a particular animal or group of animals, such as pigs or farm animals, that you might not find in books written for adults.

## FOUND OBJECTS

Found objects are natural things that add interest to your paintings, such as wildflowers, fallen logs or an ear of corn. Bring these objects into your studio and incorporate them into your paintings. Position them so the lighting is the same as in your reference photo.

### Sketching
Sketching an animal trains your artistic eye, but it also helps you get to know your subject.

# Woodland Animals

Living on a farm in Kentucky has given me the opportunity to see many kinds of wild animals that live in both open fields and wooded areas. Cottontail rabbits, white-tailed deer, chipmunks and box turtles all are found in open woodlands and in fields bordered by trees. Some of these animals can also be found in more urban settings such as school campuses, golf courses, backyards and parks.

For the black bear and the Columbian ground squirrel, I had to travel farther afield. I've observed and photographed black bears in parks, such as the Great Smoky Mountains National Park, and in zoos. Columbian ground squirrels are found in the western United States and Canada, where they inhabit meadows surrounded by forests. I was able to see these squirrels very close up during a visit to Banff National Park in Alberta, Canada.

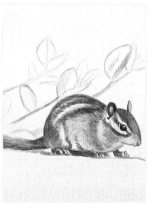   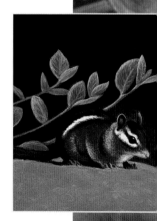

**Chipper**
Acrylic on Gessobord
8" × 10" (20cm × 25cm)

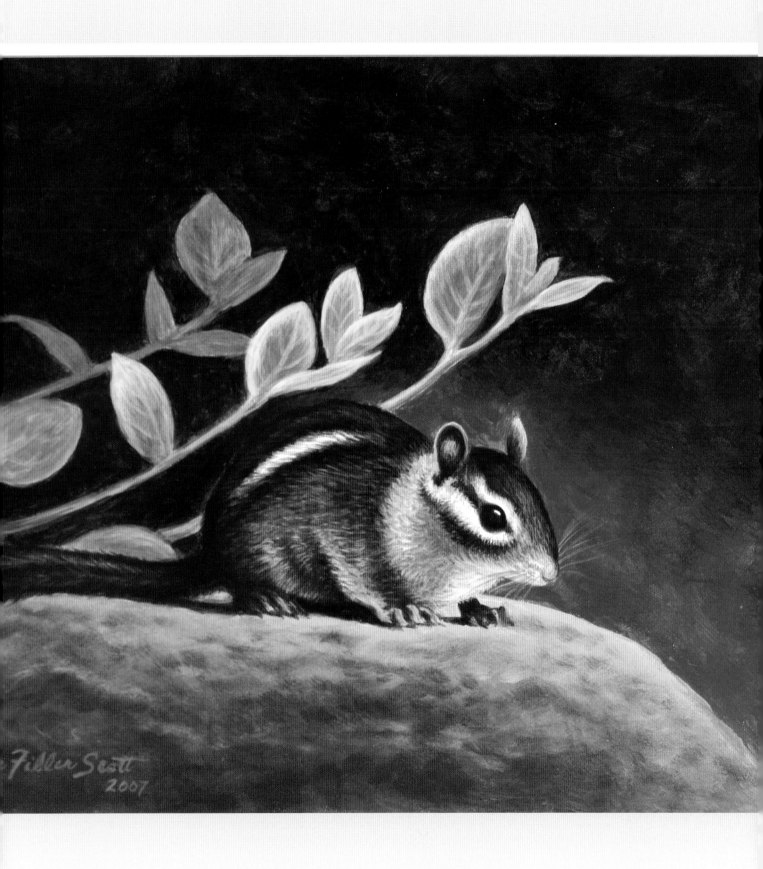

# COLUMBIAN GROUND SQUIRREL

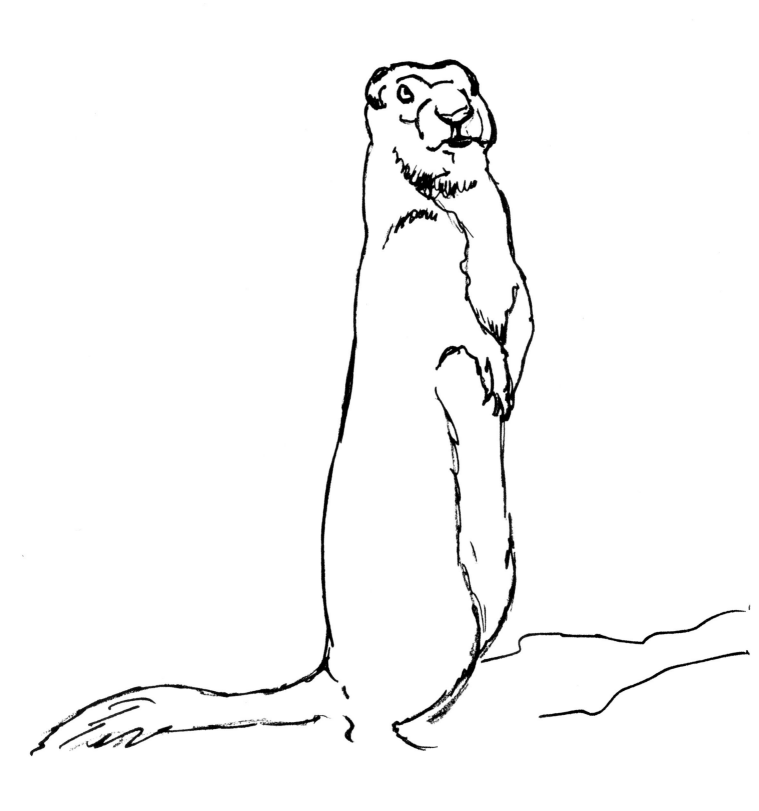

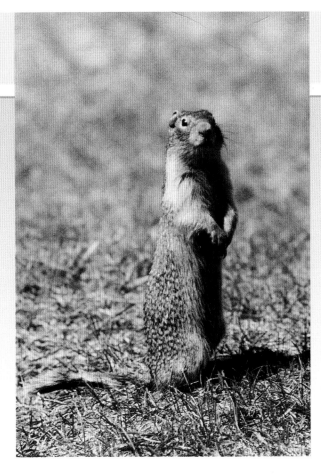

## PAINT COLORS    MIXTURES

| | |
|---|---|
|  Burnt Sienna |  dark brown |
| Burnt Umber |  dark green shadow |
| Cadmium Orange |  rufous |
| Cadmium Red Medium |  blue-gray |
| Hooker's Green Permanent |  pink |
| Raw Sienna |  field green |
| Titanium White |  fur highlight |
| Ultramarine Blue |  light blue-gray |
| Yellow Light Hansa |  light blue fur softening color |
| |  whiskers color |

### REFERENCE

*On a family trip to Banff National Park in Alberta, Canada, one of our most enjoyable experiences was meeting the Columbian ground squirrels. In one area, the squirrels were so trusting and accustomed to being fed peanuts, that if you sat down on the ground very still, they would climb onto your lap!*

### STEP 1: **ESTABLISH THE FORM**

Draw the squirrel lightly in pencil, using a kneaded eraser to lighten lines or make corrections. With Burnt Umber thinned with water and a no. 10 round, paint the basic lines and shadows. For the shadows on the squirrel, mix dark brown with Burnt Umber and Ultramarine Blue. Paint with a no. 10 round.

### BRUSHES

Nos. 3, 10 round

No. 10 bright

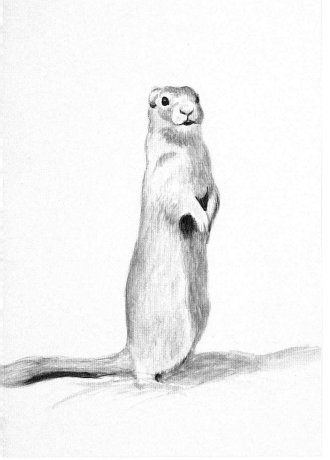

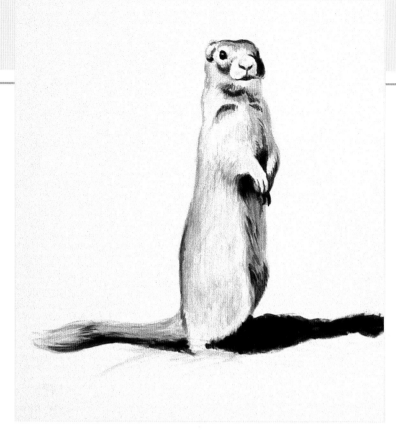

## STEP 2: **PAINT THE DARK VALUE COLORS**

Continue painting the dark areas of the squirrel with dark brown. Mix dark green for the squirrel's ground shadow with Hooker's Green Permanent, Cadmium Orange, Burnt Umber and Ultramarine Blue. Paint with a no. 10 round.

## STEP 3: **PAINT THE MIDDLE VALUE COLORS AND BEGIN PAINTING THE BACKGROUND**

Mix a light rufous color for the squirrel's coat with Burnt Sienna, Cadmium Orange and Titanium White. Paint short, parallel strokes in the direction of fur growth with a no. 10 round.

Mix blue-gray for the squirrel's belly, back and head with Titanium White, Ultramarine Blue and a small amount of Burnt Umber. Paint with a no. 10 round.

Mix pink for the nose with Titanium White, Cadmium Red Medium, Burnt Sienna and Cadmium Orange. Paint with a no. 10 round.

Mix a field green background color with Hooker's Green Permanent, Cadmium Orange, Titanium White and Raw Sienna. Paint with a no. 10 bright, using dabbing strokes. Switch to a no. 10 round to paint around the squirrel's outline.

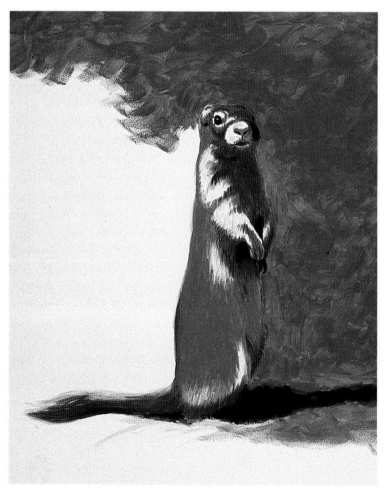

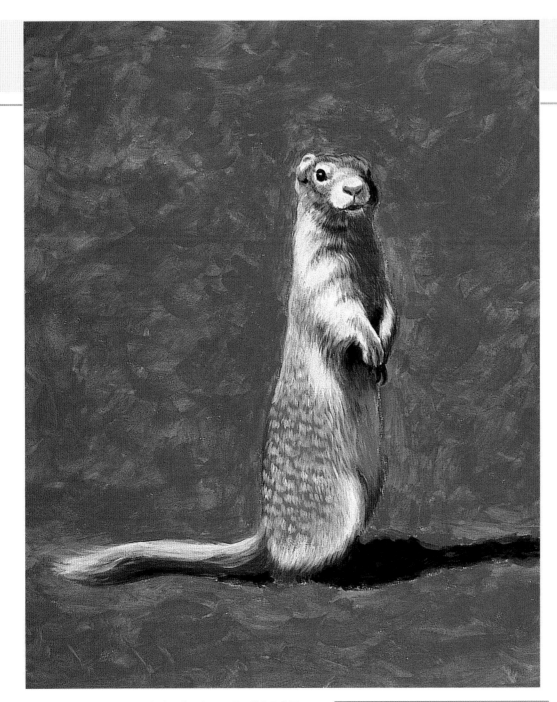

## STEP 4: **FINISH BACKGROUND COLOR AND PAINT THE LIGHT VALUE COLORS**

Finish painting the background using the field green. Mix a highlight color for the squirrel with Titanium White and small amounts of Raw Sienna and Yellow Light Hansa. Using a no. 10 round, paint parallel strokes that follow the fur pattern. Paint the mottled checkerboard pattern on the back over the blue-gray with small, parallel strokes. Overlap where the highlight meets the adjacent color with thin strokes of the highlight color. Vary the length of the strokes—longer on the body and shorter on the head and paws.

**TIP**

Create an impression of light and depth in the background by varying the amount of paint used on the panel. Allow it to show through more in some areas than in others.

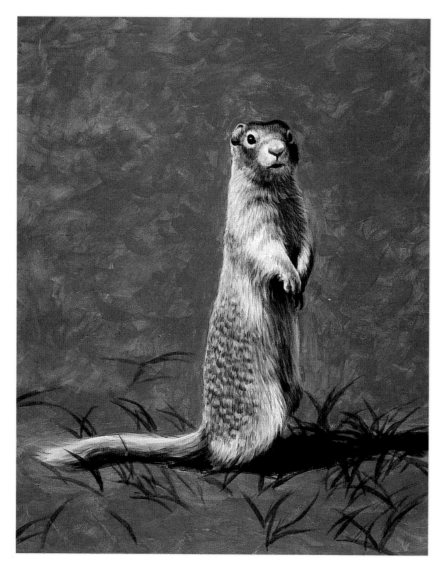

## STEP 5: **PAINT DETAILS**

Paint dark detail on the squirrel's back with dark brown and a no. 10 round, using short strokes. Soften and blend with a separate no. 10 round and blue-gray. Add dark fur detail to the belly and chest with longer strokes, softening with the adjacent color. Add detail to the highlighted areas with the rufous, using fine strokes and a small amount of paint.

Begin to paint dark blades of grass with the dark green shadow color and a no. 10 round.

### TIP

If a color looks too dark after applying it with a brush, use your fingertip to quickly blend it into the surrounding colors. In doing so, you will also remove a little of the paint.

### TIP

To make the squirrel's fur stand out against the background, transfer a portion of the highlight color to a dry palette. As the paint dries, it will become thicker and more opaque. Paint the edges of the highlighted side of the squirrel with a no. 10 round. If the paint becomes too dry, use a spray bottle to moisten it.

To make the shadowed side of the squirrel stand out, use some blue-gray mixed with Titanium White. For the chest, use light rufous mixed with Titanium White.

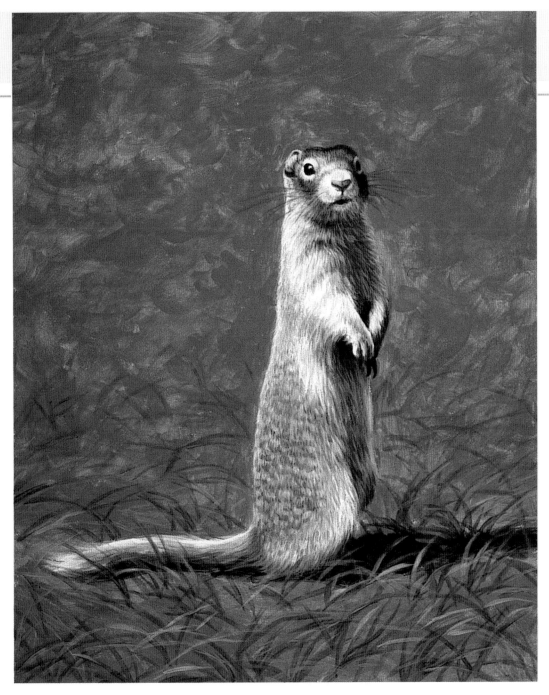

**The Sentry**
Acrylic on Gessobord
10" × 8" (25cm × 20cm)

## STEP 6: **PAINT THE FINISHING DETAILS**

On a dry palette, create the light blue fur softening color with a portion of blue-gray and some of the highlight color. With a no. 3 round, paint thin strokes over the mottled pattern on the back to soften it. Reinforce the outline of the back with the highlight color. Add some of the rufous to the back with a no. 3 round, using thin strokes.

Mix a highlight color for the eye with Titanium White and a bit of blue-gray. Use separate no. 3 rounds to paint the highlight, blending with dark brown. Reinforce the highlight with a touch of pure Titanium White.

Mix a whisker color with some dark brown and blue-gray. Paint thin, light strokes with a no. 3 round. Tone down the whiskers with the adjacent color if they come out too dark.

Paint more blades of grass with dark green and a no. 10 round. Make the strokes smaller and lighter and use less paint as you work into the background behind the squirrel. Tone down any blades that stand out too much with the field green color. Paint some blades with rufous to give the grass a more natural look.

# Cottontail Rabbit

**Painting More Animal Friends**

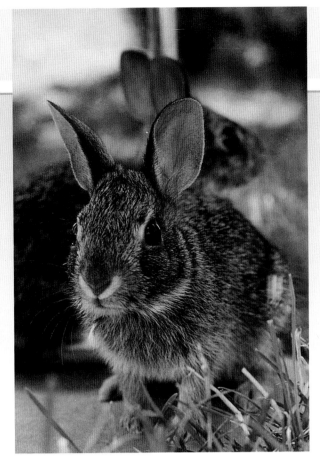

## REFERENCE

*This young cottontail was one of three orphans raised by an acquaintance who is a wildlife rehabilitator. To photograph them, I put them into an empty fish tank with a cover and placed it outside. This way, I could get down to their level for a great view without fear they would escape. They would be released into the wild later when they grew old enough to fend for themselves.*

Burnt Umber

dark brown

Cadmium Orange

medium brown

Cadmium Red Medium

grass green

Hooker's Green Permanent

light grass green

Naples Yellow

pink

Raw Sienna

pink nose

Titanium White

buff

Ultramarine Blue

fur detail

Yellow Light Hansa

brown eye

eye highlight

pink ear detail

ear shadow

grass shadow

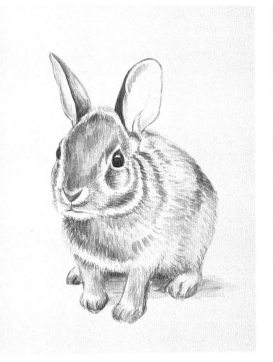

## STEP 1: ESTABLISH THE FORM

With a pencil, lightly draw the rabbit, using a kneaded eraser for corrections or to lighten lines. Paint the main lines and shading with diluted Burnt Umber and a no. 10 round.

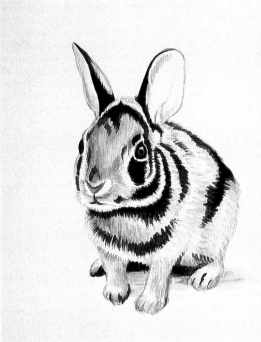

## STEP 2: PAINT THE DARK VALUE COLORS

Mix dark brown with Burnt Umber and Ultramarine Blue. Paint strokes that follow the fur growth pattern using a no. 10 round. Switch to a no. 3 round for the eyes and mouth.

### BRUSHES

Nos. 3, 10 rounds

No. 10 bright

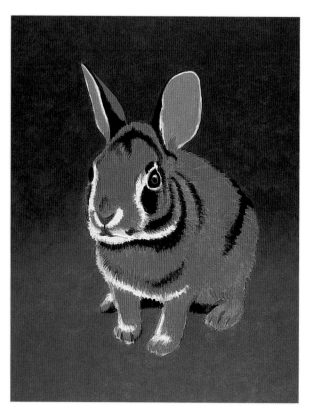

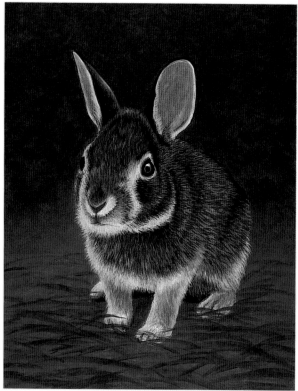

## STEP 3: **PAINT THE MIDDLE VALUE COLORS**

Mix a medium brown for the coat with Titanium White, Raw Sienna and Cadmium Orange. Paint strokes following the fur pattern with a no. 10 round.

Mix a grass green color for the upper part of the background with Hooker's Green Permanent, Cadmium Orange, Burnt Umber, Ultramarine Blue and Titanium White. Paint dabbing strokes with a no. 10 bright and use a no. 10 round around the rabbit's outline. When dry, add another layer of paint.

Mix a lighter grass green color for the lower part of the painting with Hooker's Green Permanent, Cadmium Orange, Yellow Light Hansa and Titanium White. Paint with a no. 10 bright and use a no. 10 round around the rabbit's outline.

Blend where the two greens meet using a separate brush for each color. Mix pink for inside the ears with Titanium White, Cadmium Red Medium, Raw Sienna and Cadmium Orange. Paint with a no. 10 round using smooth, vertical strokes. Mix a pink nose color with a portion of pink, plus Cadmium Red Medium, Burnt Umber and Raw Sienna.

## STEP 4: **PAINT LIGHT VALUE COLORS AND BEGIN TO ADD DETAIL**

Transfer portions of the dark brown and medium brown to a dry palette. Paint fur detail using a separate no. 10 round for each color, overlapping the medium brown areas with dark brown detail and the dark areas with medium brown detail. Use strokes that follow the fur pattern.

Mix a buff color for the lighter value areas of the coat with Titanium White, Naples Yellow, Cadmium Orange and Raw Sienna. Paint with a no. 10 round.

With a no. 10 round, paint a glaze of Burnt Sienna and water over the rabbit. Mix a fur detail color with a portion of medium brown, Burnt Sienna and Raw Sienna. With a no. 3 round, paint fur detail with small strokes using it to integrate the dark shadows in the fur with the medium brown areas. Also, use this color to blend where the dark areas meet the light value areas. Add more buff detail with a no. 3 round. Use the fur detail color and a no. 3 round to add more detail to the buff areas. With sweeping strokes, paint some blades of grass with the lighter grass green color and a no. 10 round.

## STEP 5: **PAINT THE FINISHING DETAILS**

Mix a brown eye color with Burnt Sienna, Burnt Umber, Raw Sienna and Titanium White. Paint with a no. 3 round, blending with dark brown and a separate no. 3 round. Mix the eye highlight color with Titanium White and a touch of Ultramarine Blue. Paint the highlight with a no. 3 round, blending the edges with the brown eye color.

Blend the dark outline of the eye with the medium brown. Paint a small vertical arc of the brown eye color in the right eye, then paint a small highlight in the upper part of the eye. Darken and soften the eyes by painting a glaze of Burnt Umber and water over the brown part of the eyes.

Add more detail to the fur using the brown eye color and a no. 3 round. Paint with small, thin strokes. Add more detail with the buff color. Mix a pink ear detail color with Titanium White, Cadmium Red Medium, Cadmium Orange and Burnt Umber, then paint veins in the left ear with light pressured strokes using a no. 3 round. Paint shaded areas in the left ear with parallel strokes, blending with the pink. Create an ear shadow color with some of the fur detail color mixed with some of the brown eye color. Paint shadows inside the ears with a no. 10 round, using parallel strokes.

Mix a grass shadow color with a portion of the grass green color, Burnt Umber and Ultramarine Blue, then paint a shadow under the rabbit with a no. 10 round. Paint some strokes in the grass, then paint some slightly curved, horizontal strokes with the fur detail color. Add a few strokes of buff to the grass, blending with the fur detail color.

Paint the whiskers with a no. 3 round, using dark brown for the base of the whiskers and buff for the rest. Paint lightly, with long, thin, curving strokes. Tone down as needed with the adjacent color.

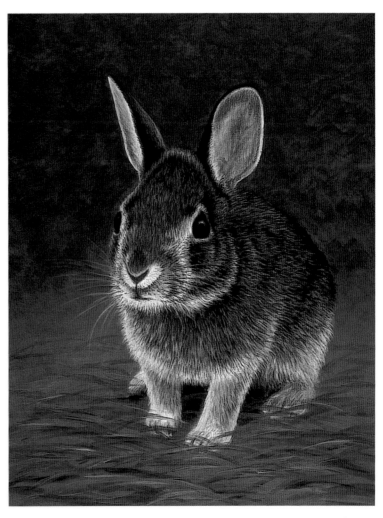

**Bunny Business**
Acrylic on Gessobord
10" × 8" (25cm × 20cm)

**TIP**

When paints on the dry palette begin to harden, wet them lightly with the spray bottle.

**TIP**

It's better not to paint the background color too solid. Leave some thinner areas where the panel shows through the paint to allow the background to breathe and to have depth.

# WHITE-TAILED DEER

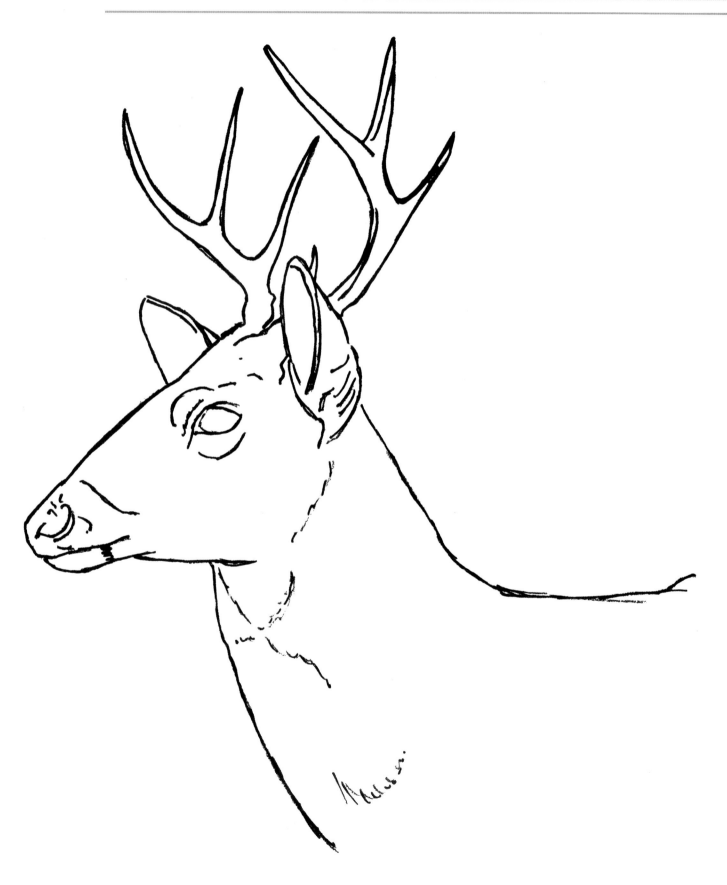

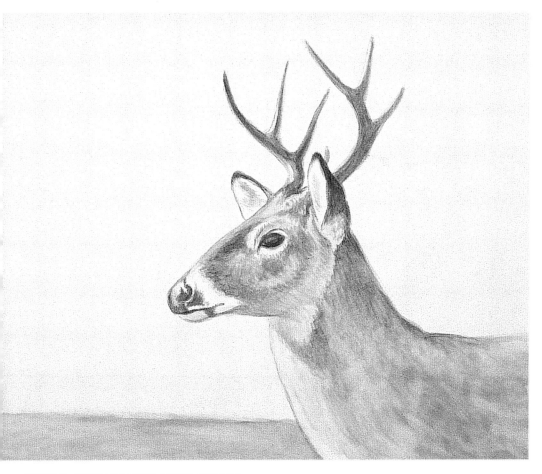

## REFERENCE

*This young buck showed up on a thoroughbred horse farm in Midway, Kentucky. The deer had likely been raised by people since he had no fear of humans and would eat out of a horse bucket. The farm owners eventually gave him to a wild animal park to roam with a captive deer herd.*

Burnt Sienna   dark brown

Burnt Umber   green field

Cadmium Orange   medium brown

Cadmium Red Medium   pink

Hooker's Green Permanent   buff

Naples Yellow   blue shadow

Titanium White   blue sky

light blue sky

Ultramarine Blue  warm white

 warm black

 light brown tree line color

 field highlight

## BRUSHES

Nos. 1, 3, 4 and 5 rounds
No. 8 shader

## STEP 1: ESTABLISH THE FORM

Lightly draw the deer in pencil on the panel, using a kneaded eraser to make corrections or lighten lines. Paint the basic lines and shading using a no. 10 round and Burnt Umber thinned with water.

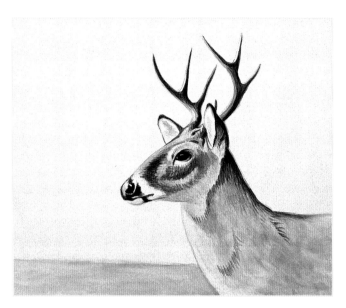

## STEP 2: **PAINT THE DARK VALUE COLORS**

Mix dark brown with Burnt Umber and Ultramarine Blue. Paint the darkest areas with a no. 10 round.

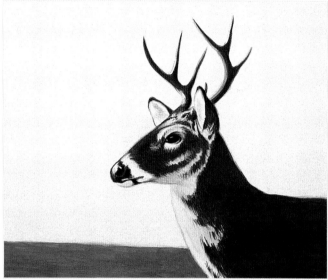

## STEP 3: **PAINT THE MIDDLE VALUE COLORS**

Mix a green field color with Hooker's Green Permanent, Burnt Umber, Cadmium Orange, Naples Yellow and Titanium White. Paint smooth, horizontal strokes with a no. 10 round.

To paint the deer's coat and antlers, mix medium brown with Burnt Umber, Burnt Sienna, Cadmium Orange and Titanium White. With a no. 10 round, use brushstrokes that follow the hair pattern.

## STEP 4: **PAINT THE LIGHT VALUE COLORS**

Mix pink with Titanium White, Naples Yellow, Cadmium Orange and small amounts of Cadmium Red Medium and Burnt Sienna. Paint parallel strokes inside the ears and around the nostril with a no. 10 round.

Mix a buff color for the highlighted areas of the coat with Titanium White, Cadmium Orange and Naples Yellow. Paint parallel strokes following the hair pattern with a no. 10 round. Blend the edges where colors meet with a separate no. 10 round and the adjacent color. Paint the antler highlights with buff and a no. 10 round.

Mix a blue shadow color with Titanium White and small amounts of Ultramarine Blue and Burnt Umber. Paint the shaded white areas (the muzzle, neck and base of the ear) with a no. 10 round, blending the edges with the adjacent color.

Mix a blue sky color with Titanium White, Ultramarine Blue and a small amount of Naples Yellow. Begin to paint with a no. 10 bright, using dabbing and semicircular strokes. Switch to a no. 10 round to paint around the deer's outline.

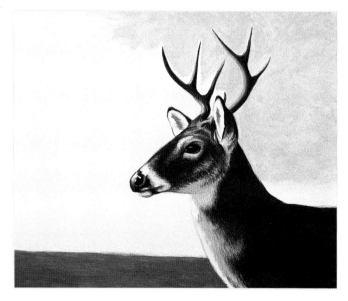

## STEP 5: FINISH THE SKY, ADD HIGHLIGHTS AND BEGIN DETAIL

Mix a lighter sky color with a portion of the blue sky color and Titanium White. Paint the sky at the horizon line, blending upward with a separate no. 10 bright and the blue sky color.

Mix a warm white with Titanium White and a touch of Naples Yellow. Paint the highlights on the ears, head, neck and antlers with a no. 10 round. Blend the edges with the adjacent color.

Mix warm black with Burnt Umber and Ultramarine Blue. Add dark accents to the ears, antlers and muzzle, and darken the eye with a no. 10 round. Paint dark detail in the coat with a no. 10 round, using light pressured strokes that follow the hair pattern. Use medium brown to add detail to the buff and blue shadow color areas. Lightly blend with the adjacent color.

## STEP 6: PAINT THE FINISHING DETAILS

Continue to add dark detail to the coat, blending and softening with the medium brown and a separate brush. Use medium brown to add detail to the reflective part of the neck, softening and blending with warm white. Add lighter detail with buff and a no. 10 round, blending and softening with a separate brush and medium brown.

Add knobby detail to the base of the antlers and strengthen highlights on the antlers' tines. Add detail to the muzzle and darken the underside of the chin. Paint a highlight in the eye with the blue sky color and a no. 3 round. Blend with warm black using a separate no. 3 round.

To paint the field's horizon, mix a light brown tree line color with Titanium White, Burnt Umber and a touch of Burnt Sienna. Paint with a no. 10 round, using light, sketchy strokes.

Mix a field highlight color with Titanium White, Hooker's Green Permanent, Cadmium Orange and Naples Yellow. Paint sketchy horizontal strokes over the grassy field. Add a few light touches of medium brown and blend with the green field.

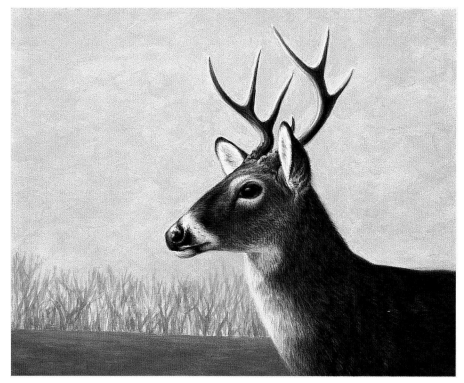

**Nobility**
Acrylic on Gessobord
8" × 10" (20cm × 25cm)

# CHIPMUNK

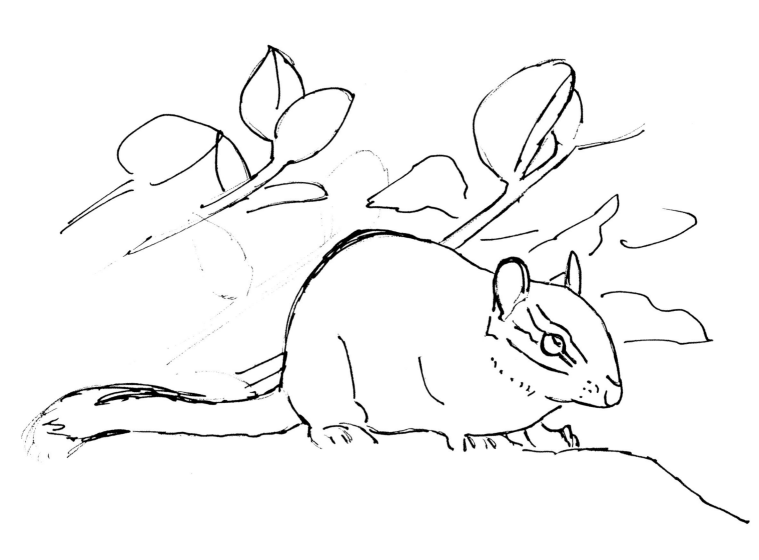

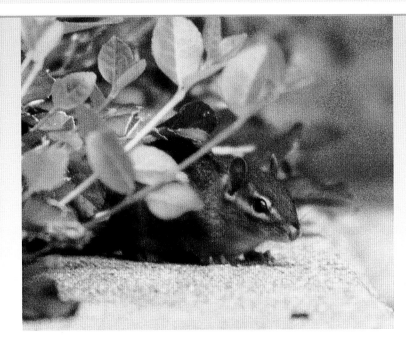

## REFERENCE

*Chipmunks are delightful creatures. They are also very difficult to photograph! I saw this chipmunk at the University of Kentucky campus, where they are used to people feeding them and walking close by. It took a great deal of patience to get close enough to capture the elusive little animal on film.*

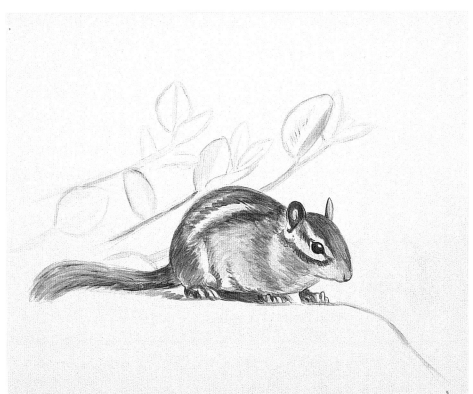

## STEP 1: ESTABLISH THE FORM

Use a pencil to lightly draw the chipmunk, rock and plants onto the panel, using a kneaded eraser for corrections or to lighten lines. Use a no. 10 round and diluted Burnt Umber to paint the main lines. Switch to a no. 3 round for the smaller details.

## STEP 2: PAINT THE DARK VALUE COLORS

Mix warm black with Burnt Umber and Ultramarine Blue. Paint the back, tail and shadows of the chipmunk with a no. 10 round. Use a no. 3 round to paint the eyes, ears and other small details.

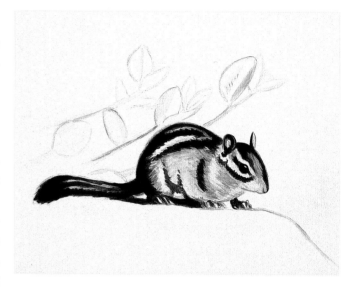

## STEP 3: PAINT THE MIDDLE VALUE COLORS

Mix a reddish coat color with Burnt Sienna, Cadmium Orange and Burnt Umber. Paint with a no. 10 round, blending with warm black and a separate no. 10 round. Use strokes that follow the fur pattern.

Mix green plant color with Hooker's Green Permanent, Cadmium Orange, Yellow Light Hansa and Titanium White. Paint the plants with a no. 10 round. Mix a rock color with Titanium White, Raw Sienna and Burnt Umber. Paint the rock with dabbing strokes, using a no. 10 bright. Switch to a no. 10 round for around the chipmunk's feet and tail.

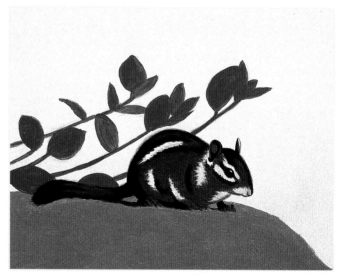

## STEP 4: PAINT THE LIGHT VALUE COLORS AND THE BACKGROUND COLOR AND ADD DETAIL

Mix a dark green background color with Hooker's Green Permanent, Burnt Umber, Cadmium Orange and Ultramarine Blue. Mix a lighter green for the lower part of the painting by adding Titanium White to a portion of dark green. Paint with no. 10 brights, blending where one color meets the other and using dabbing strokes. Use no. 10 rounds for painting around the chipmunk and plants.

Mix a buff color for the lighter parts of the chipmunk's coat with Titanium White, Naples Yellow, Cadmium Orange and Raw Sienna. Using a no. 10 round, paint strokes that follow the fur pattern, then switch to a no. 3 round for the smaller details.

Mix a cream color for the lightest parts of the chipmunk with a portion of the buff color and Titanium White. Paint the white stripes on the body's side and around the eye with a no. 3 round.

Mix yellow-green for the highlights on the plants with some of the green plant color mixed with Titanium White, Yellow Light Hansa and a touch of Cadmium Orange. Using a no. 10 round, paint highlights and details with smooth strokes, blending with the green plant color.

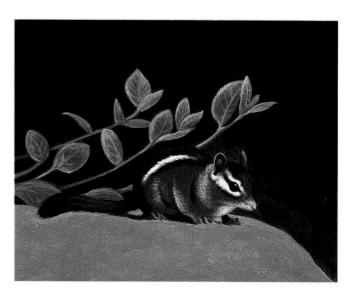

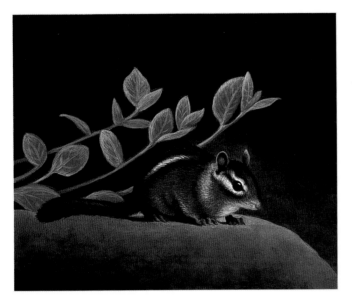

## STEP 5: **ADD DETAIL TO THE ROCK AND FUR**

Mix a medium rock shadow color with Titanium White, Raw Sienna and Burnt Umber. With dabbing strokes and a no. 10 bright, paint the lower part of the rock, leaving the upper part and the right edge the original color. Use a separate no. 10 bright and the rock color to blend where the two colors meet. Mix a dark rock shadow color with a portion of the medium rock shadow color, Burnt Umber and Ultramarine Blue. Paint the lower edge of the rock with a no. 10 bright, blending up into the medium rock shadow color. Re-establish the rock color where needed, blending into the adjacent color with the dry-brush technique.

Using no. 3 rounds, add detail to the fur with warm black and the reddish and buff colors, blending with the adjacent color.

## STEP 6: **PAINT THE FINISHING DETAILS**

Paint a thin glaze of the reddish color mixed with water over the plants with a no. 10 round. This will help integrate the chipmunk and background.

Use a no. 10 round to paint a glaze of dark green and water over the plants farthest in the background. Smooth the plants out by lightly painting over them with the lighter green and a no. 10 round. Re-establish highlights as needed with yellow-green.

Mix a rock detail color with some of the rock shadow and reddish colors. With a small amount of semi-dry paint on a no. 6 bright, use broken, dabbing strokes to create texture and shadow detail. With a no. 2 bright and the rock color, paint highlights using the same technique.

Paint the whiskers with very thin, slightly curving strokes, using a small amount of buff and a no. 3 round. For the portion of the whiskers that overlap the muzzle, use the rock detail color.

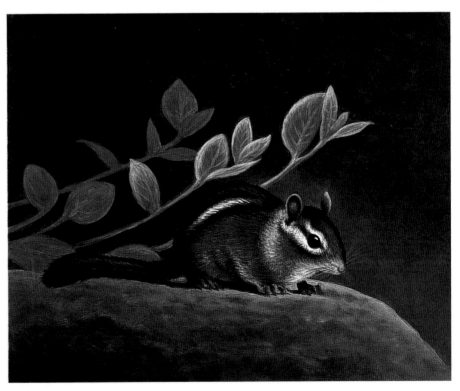

**Chipper**
Acrylic on Gessobord
8" × 10" (20cm × 25cm)

# BLACK BEAR

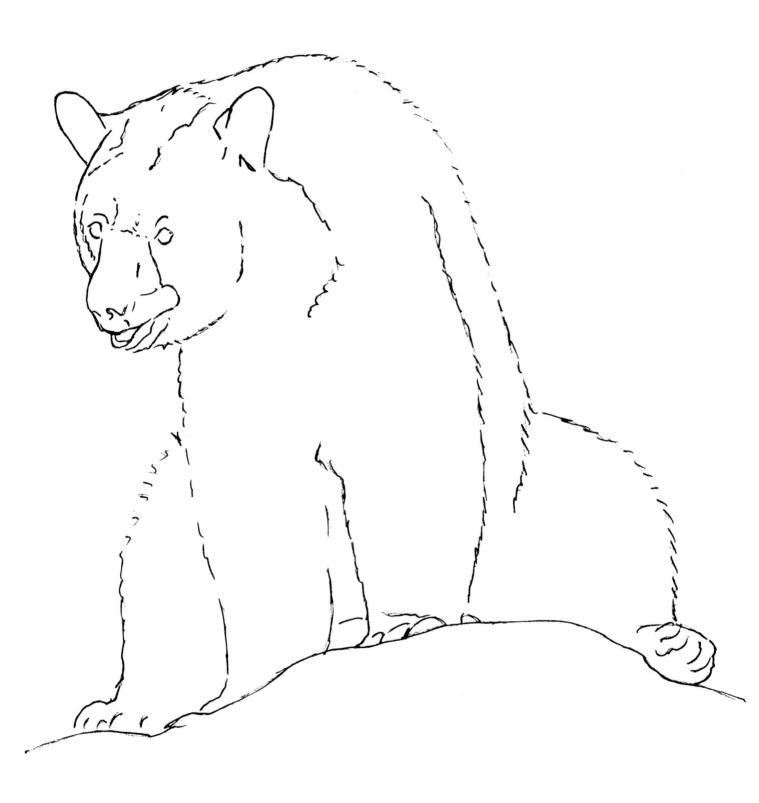

**Painting More Animal Friends**

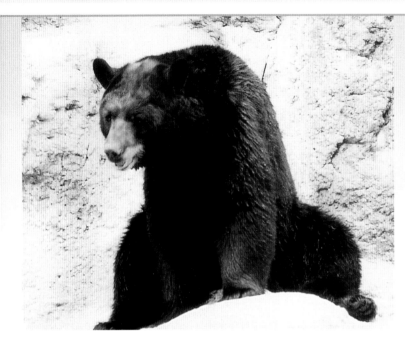

## REFERENCE

*This black bear lived in
an outdoor enclosure
at the Arizona Sonora
Desert Museum in
Tucson, Arizona.
I've seen wild black
bears in the U.S. and
Canada, but I have
never been able to get a
good reference photo in
their natural habitat.
Eventually, this bear
struck a relaxed pose that
I wanted to paint.*

 Burnt Umber

 black

 Cadmium Orange

 slate blue

 Cadmium Red Medium

 grayish brown

Cerulean Blue

 tan

Hooker's Green Permanent

pink

Naples Yellow

light pink

 Raw Sienna

 forest green

Titanium White

 dark slate blue

Ultramarine Blue

bright highlight

 dark mossy green

 pine branch

 medium mossy green

 moss highlight

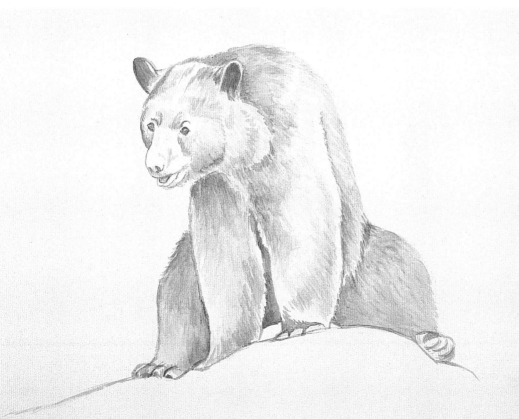

## STEP 1: **ESTABLISH THE FORM**

Draw the bear lightly in pencil, using a kneaded eraser for corrections or to lighten lines.
With diluted Burnt Umber and a no. 10 round, paint the main lines and the form of the bear.

## BRUSHES

Nos. 3, 10
rounds
Nos. 6, 8
brights

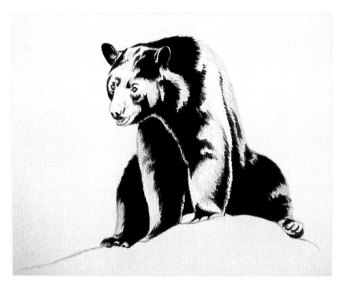

## STEP 2: **PAINT THE DARK VALUE COLORS**

Mix a black fur color for the bear's coat with Burnt Umber and Ultramarine Blue. Paint the darkest parts of the coat with a no. 10 round, using strokes that follow the fur growth pattern. Switch to a no. 3 round for facial details. For darkest coverage, keep adding layers of paint after the first layer has dried.

## STEP 3: **PAINT THE MIDDLE VALUE COLORS**

Mix a slate blue fur color with Titanium White, Ultramarine Blue and Burnt Umber. Paint with a no. 10 round. Mix a grayish brown for the rock with Titanium White, Burnt Umber and Ultramarine Blue and use a no. 10 bright.

Mix tan for the muzzle with Titanium White and Raw Sienna. Paint with a no. 10 round. Mix pink for the tongue with Titanium White, Cadmium Red Medium and Naples Yellow, and paint with a no. 3 round. Mix a lighter pink for the bear's lip by adding more Titanium White to the mixture. Mix a brown eye color with Raw Sienna and Burnt Umber. With a no. 3 round, paint the eyes and define the mouth.

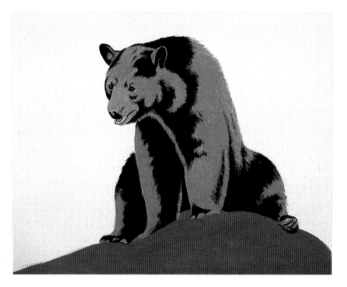

## STEP 4: **PAINT THE BACKGROUND COLOR AND BEGIN TO ADD DETAIL**

Add warmth to the bear and rock by painting a thin (but not soupy) glaze of Burnt Umber over the entire area with a no. 6 bright. Paint thinly so that the original colors show through the glaze. When dry, add more glazes as needed.

With a no. 10 round and the black fur color, add detail to the lighter areas of the coat using strokes that follow the fur pattern. When adding detail to the muzzle, paint with very light-pressured strokes. Paint the highlighted part of the nose with the slate blue color, blending with the black fur color.

Mix a forest green color with Hooker's Green Permanent, Burnt Umber, Cerulean Blue and a small amount of Titanium White. To paint the background, use dabbing strokes with a no. 5 bright.

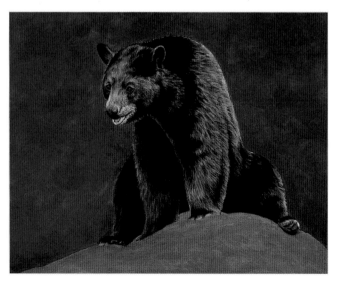

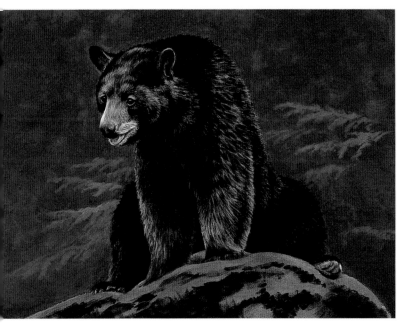

## STEP 5: **ADD MORE DETAIL**

Mix a dark slate blue fur color with a portion of the slate blue fur color, Burnt Umber and Ultramarine Blue. Lightly paint fur detail in the dark areas of the coat with a no. 10 round.

Mix a light highlight color with Titanium White and a touch of the slate blue fur color. Paint highlights in the coat sparingly with a no. 3 round, as well as in the eyes and on the face.

Mix a dark mossy green for the rock with a portion of forest green mixed with Burnt Umber and Ultramarine Blue. Use a no. 6 bright to paint broken, dabbing strokes.

Mix a pine branch color with Hooker's Green Permanent, Burnt Umber, Titanium White and Naples Yellow. Paint a few sketchy branches in the background using a no. 10 round.

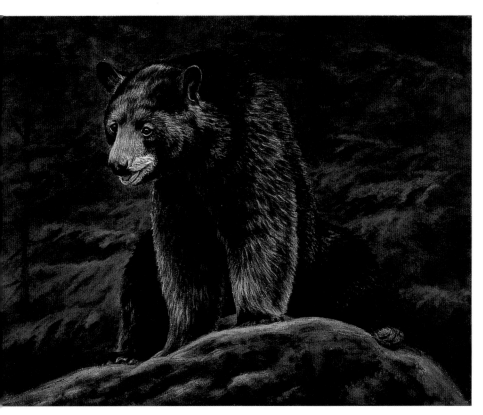

**Rock Sitter**
Acrylic on Gessobord
9" × 12" (23cm × 30cm)

## STEP 6: **PAINT THE FINISHING DETAILS**

Mix a medium mossy green for the rock with Hooker's Green Permanent, Naples Yellow, Burnt Umber, Cadmium Orange and a small amount of Ultramarine Blue. Paint with a no. 6 bright, using a clean no. 6 bright for the dark mossy green. Paint with dabbing strokes, roughly blending where the two colors meet.

Mix a moss highlight color with a portion of the medium mossy green, Titanium White and Naples Yellow. Paint highlights with a no. 10 round, blending where the colors meet with separate no. 10 rounds for the medium and dark mossy greens.

Lightly paint some medium mossy green over the highlighted parts of the bear's coat with a no. 10 round following the original strokes.

With a no. 8 bright and the dark mossy green, paint darker areas over the background with loose, dabbing strokes. Allow some of the original color to show through in places. Tone down the pine branches with a glaze of diluted dark mossy green.

# Box Turtle

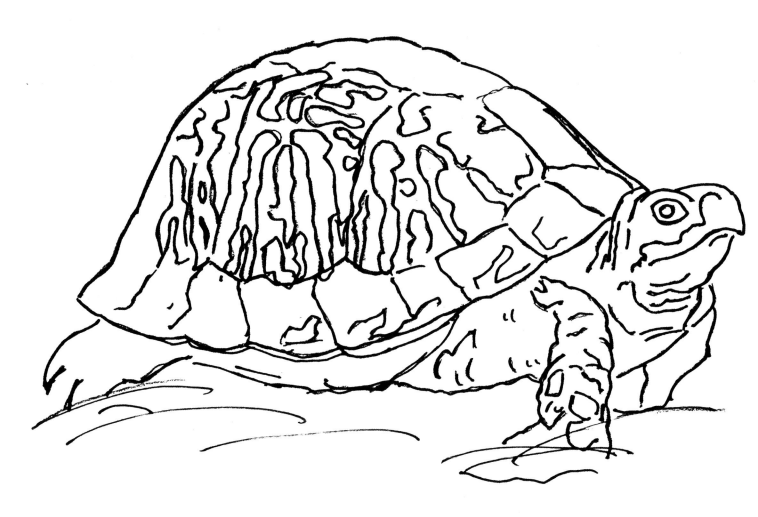

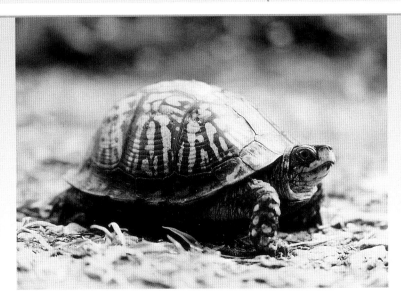

## REFERENCE

*Box turtles are harmless
creatures that are a
delight to encounter
during a walk in the
woods or fields. Their
hard shells are no match
for a heavy car. Every
spring our family rescues
dozens of box turtles from
the road and relocates
them to safer areas.*

Burnt
Sienna     warm black

Burnt
Umber     yellow-orange

Cadmium
Orange    blue-gray

Cadmium
Red
Medium     dark green

Hooker's
Green
Permanent     dark brown

reddish brown

Naples
Yellow     highlight

Scarlet Red     eye highlight

Titanium
White     secondary
highlight

Ultramarine
Blue     pink

warm highlight
glaze

 grass green

 grass highlight

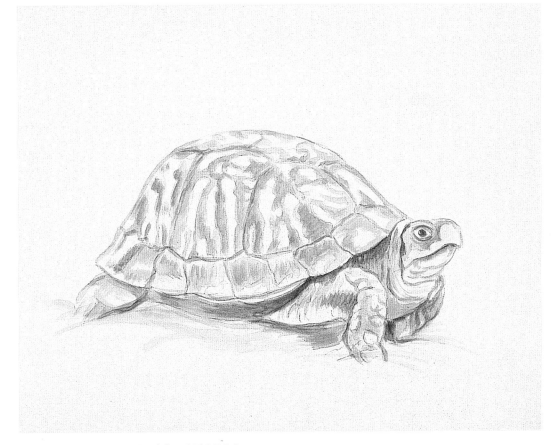

## STEP 1: **ESTABLISH THE FORM**

Draw the turtle lightly in pencil, using a kneaded eraser to make any corrections.
Paint the main lines with diluted Burnt Umber and a no. 10 round.

### BRUSHES

Nos. 3, 10
rounds
No. 10 bright

## STEP 2: **PAINT THE DARK VALUE COLORS**

Mix warm black for the shell and body with Burnt Umber and Ultramarine Blue. Paint with a no. 10 round.

**TIP**

If your paint becomes too watery on the Sta-Wet Palette, transfer a portion of the paint to a piece of wax paper. This will give you a more opaque and darker black. Spray occasionally with an atomizer bottle (like a perfume bottle) to keep from drying out.

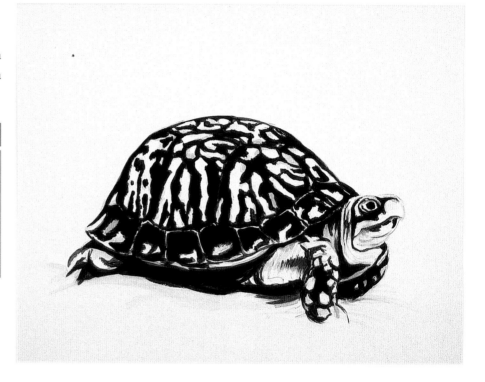

## STEP 3: **PAINT THE MIDDLE VALUE COLORS**

Sketch in the toes on the front foot with a no. 3 round and warm black. Mix yellow-orange for the turtle's markings with Naples Yellow, Cadmium Orange and a small amount of Burnt Sienna. Paint with a no. 10 round.

Mix blue-gray with Titanium White, Ultramarine Blue and a small amount of Burnt Umber. Paint the seams of the shell and around the eye with a no. 3 round.

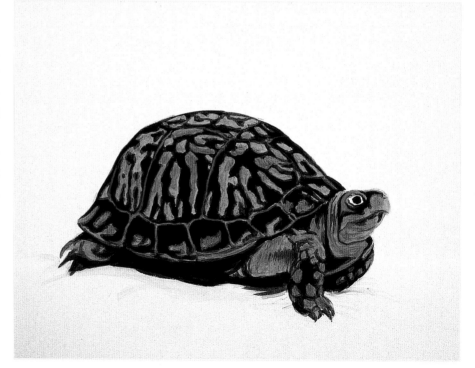

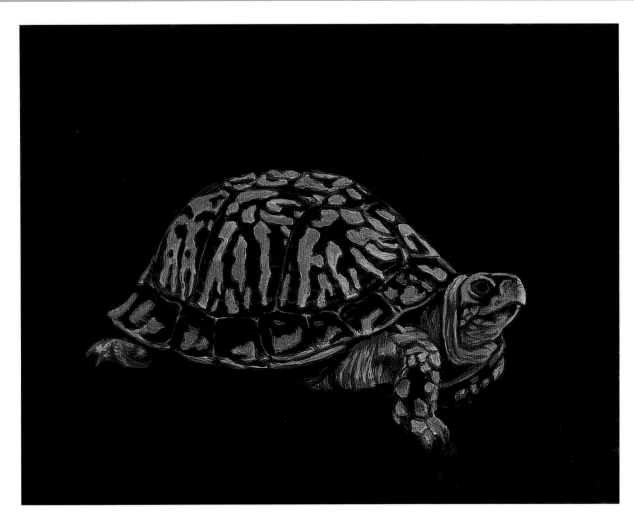

## STEP 4: **PAINT THE BACKGROUND AND ADD DETAIL**

Mix dark green for the background with Hooker's Green Permanent, Burnt Umber and Burnt Sienna. Paint with a no. 10 bright, using dabbing, semicircular strokes. Use a no. 10 round to paint around the turtle's outline. When dry, paint another layer over the dark green to strengthen coverage.

Reinforce the yellow-orange areas with a no. 10 round. Do the same with the warm black areas and refine the blue-gray lines that mark the plates of the shell.

Use a no. 10 round with blue-gray to add horizontal line detail to the shell with light, sketchy strokes. Tone down as needed with warm black.

To create dark brown, mix Burnt Umber with a small amount of warm black. With a no. 10 round, lightly paint line detail on the turtle's head, neck and legs, using a clean no. 10 round and yellow-orange to blend and soften.

Mix reddish brown for the eye with Burnt Sienna and Cadmium Orange. Paint with a no. 3 round, using a separate no. 3 round to reinforce and blend the pupil and the outline of the eye.

**TIP**

Use your artistic license to place the turtle in a setting that will make it stand out and give it a more atmospheric look. The dark green background color contrasts nicely with the highlighted shell.

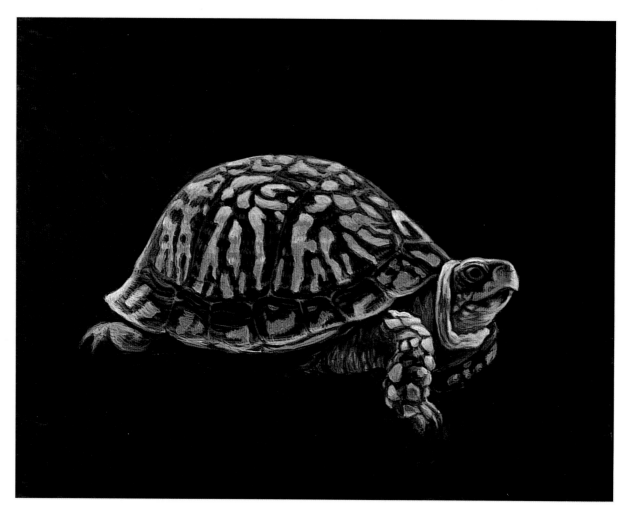

## STEP 5: **PAINT LIGHT VALUE COLORS AND HIGHLIGHTS**

With a no. 10 round, paint a glaze of diluted warm black over the blue-gray areas to tone down and integrate the light value colors.

Mix a highlight color with Titanium White and a small amount of Naples Yellow. Paint highlights on the head, neck, right front leg and shell with a no. 3 round, using a separate no. 3 round to blend with the adjacent color.

Mix a highlight color for the eye with Titanium White and a bit of blue-gray. Paint with a no. 3 round, blending with the adjacent color using a separate no. 3 round. Mix the blue highlight color for the shell with the highlight color and a bit of blue-gray. Paint with a no. 3 round, using the dry-brush technique.

Mix a secondary highlight color for the head, neck and right front leg with Titanium White and yellow-orange. Paint with a no. 3 round.

**TIP**

The dry-brush technique requires just enough paint and moisture on your brush that you don't completely cover the underlying paint layer when you lay down a stroke.

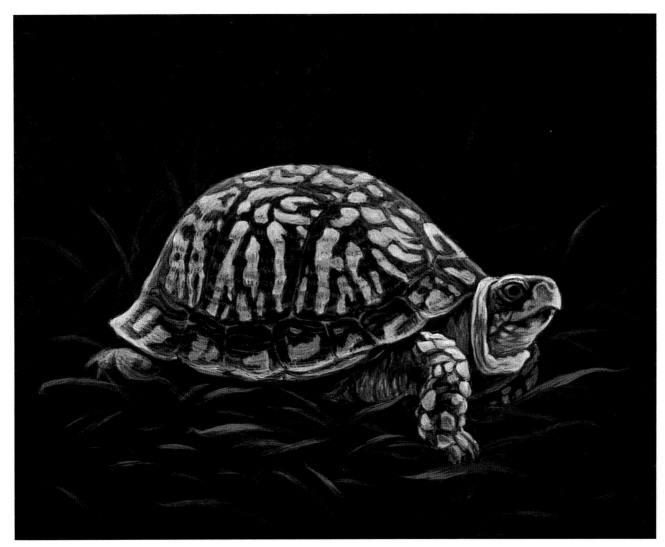

## STEP 6: **PAINT THE FINISHING DETAILS**

Strengthen the highlights on the shell behind the head. Use a no. 3 round and warm black to paint dark line detail across the yellow-orange shell markings. Tone down as needed with thin strokes of yellow-orange.

Mix pink for the nostril with Scarlet Red, Burnt Sienna and a touch of Titanium White. Paint with a no. 3 round, blending around the edges with a separate brush and the adjacent color.

Glaze the left front leg and right hind leg with diluted dark brown and a no. 10 round.

Make a warm highlight glaze color with a diluted mixture of Naples Yellow and Cadmium Orange. Use a no. 3 round to paint a very thin glaze over the brightest highlights.

Mix a grass green color with Hooker's Green Permanent, Cadmium Orange, Burnt Umber and a bit of Titanium White. Paint blades of grass with light, thin strokes. Mix a grass highlight color with some of the green grass color mixed with Titanium White, Naples Yellow and more Cadmium Orange. Lightly paint highlights on selected blades.

**Boxy but Good**
Acrylic on Gessobord
8" × 10" (20cm × 25cm)

**TIP**

Vary the amount of pressure and paint on your brush so some of the highlights recede more than others.

# PART TWO

# BABY ANIMALS

Baby animals are exceptionally appealing subjects. They have large eyes, short muzzles, rounded heads and soft fur. Some baby animals, such as horse or zebra foals, also have long, gangly legs. When drawing or painting young animals, keep in mind that their proportions are different from those of an adult of the same species. Also, their expressions often seem naïve and are usually soft focused.

One of my most enjoyable experiences was successfully raising five orphaned baby opossums. When rescued, they were about the size of mice. They became so tame that they would sit on my shoulder—until they became too big to do so. Places to observe and photograph baby animals include zoos, farms, county fairs, wildlife parks and veterinary clinics that take in wild animals. You can also contact wildlife rehabilitators.

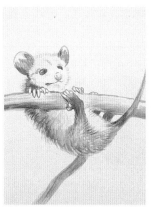   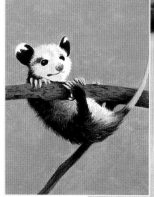

**The Acrobat**
Acrylic on Gessobord
8" × 10" (20cm × 25cm)

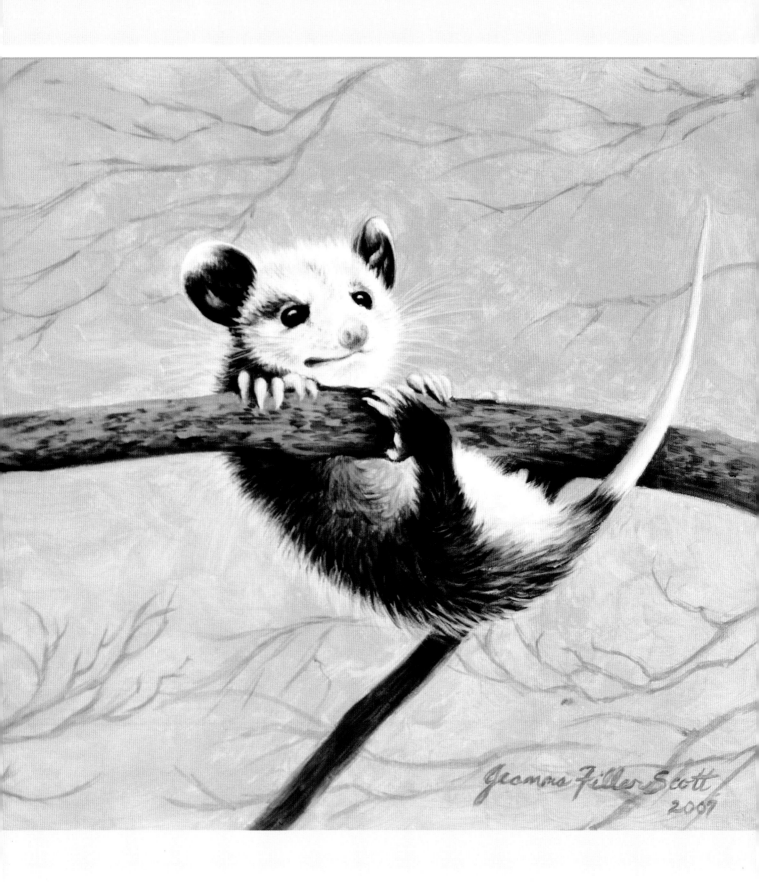

# Raccoon Baby

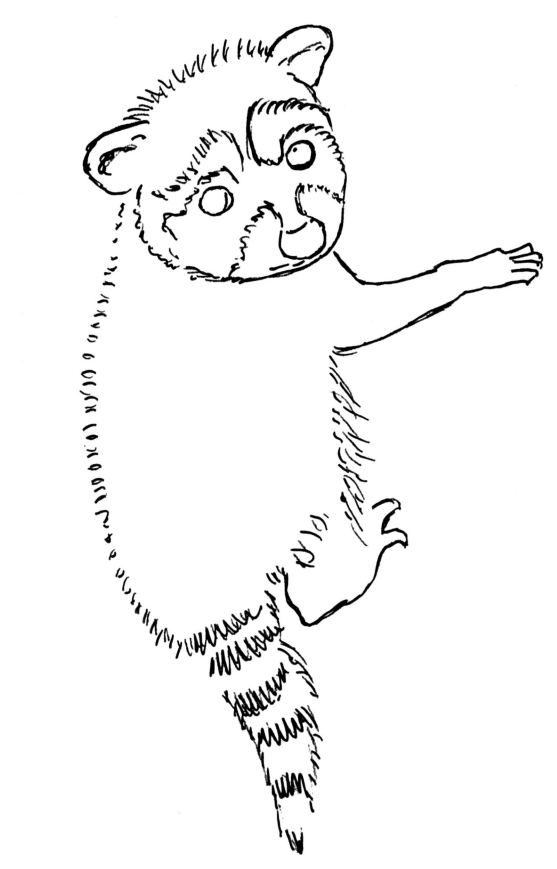

**Painting More Animal Friends**

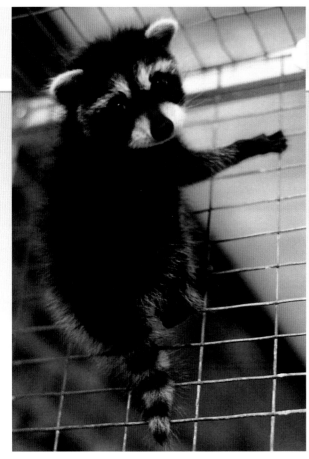

## PAINT COLORS

■ Burnt Umber

■ Cadmium Orange

■ Hooker's Green Permanent

■ Raw Sienna

□ Titanium White

■ Ultramarine Blue

Yellow Light Hansa

## MIXTURES

 warm black

 warm gray

 buff

 blue shadow

white fur

 dark buff

 dark blue shadow

 mossy green

### REFERENCE

*This orphaned baby raccoon was taken in by a veterinary clinic in Lexington, Kentucky, where they care for wildlife in need. This baby was irresistible, with his wide-eyed, intelligent, yet naïve expression. He definitely needed help, and I'm glad he was able to get it.*

## STEP 1: **ESTABLISH THE FORM**

Draw the raccoon lightly in pencil, using a kneaded eraser for corrections or to lighten lines. Use diluted Burnt Umber and a no. 10 round to paint the main lines and the form.

### BRUSHES

Nos. 3, 10 rounds

No. 10 bright

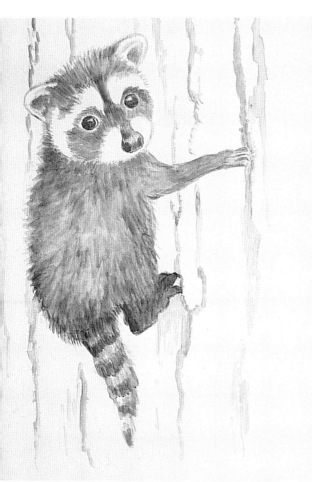

## STEP 2: **PAINT THE DARK VALUE COLORS**

Mix warm black with Burnt Umber and Ultramarine Blue. Paint the black parts of the raccoon with a no. 10 round, using parallel strokes that follow the hair growth pattern.

When painting the eyes, leave the highlighted parts unpainted. For good, dark coverage, paint more layers after the first layer has dried. Paint cracks in the tree bark with the same brush and color.

## STEP 3: **PAINT THE MIDDLE VALUE COLORS**

Mix warm gray for the tree trunk with Titanium White, Burnt Umber and Ultramarine Blue. Paint the trunk using vertical strokes with a no. 10 bright. Use a no. 10 round to paint around the raccoon's outline.

Mix a buff color with Titanium White, Raw Sienna and a touch of Cadmium Orange. Paint the shaded areas of the mask and ears and the light tail rings with a no. 10 round.

Mix a blue shadow color with Titanium White, Ultramarine Blue and a small amount of Burnt Umber. Paint the lower muzzle, inside the ears and the nose highlight with a no. 10 round. Use a no. 3 round to paint the whites of the eyes using the same color.

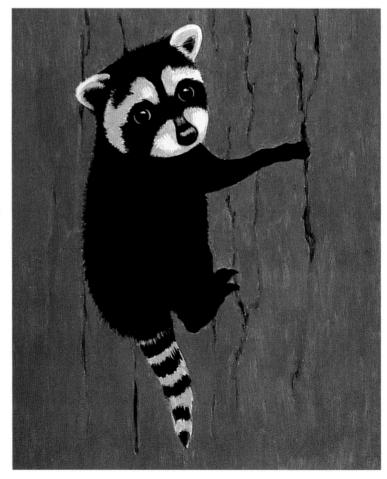

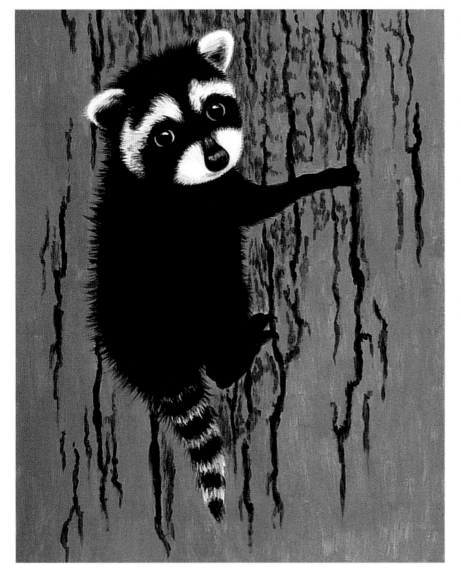

## STEP 4: **PAINT THE LIGHT VALUE COLORS**

Mix a white fur color with Titanium White and a touch of Yellow Light Hansa. Paint the white parts of the face and ears with a no. 10 round. Use overlapping strokes that follow the fur pattern.

With warm black and a no. 10 round, paint the longer hairs along the back, head, belly and tail using slightly curving strokes. Paint shorter strokes at the edges where the white fur meets the black fur.

Reinforce the cracks in the tree bark and add detail to the warm gray areas using a no. 10 round with less paint while applying lighter pressure on the brush. Paint bark details with short vertical strokes. Add secondary cracks that are long, but thinner than the main cracks.

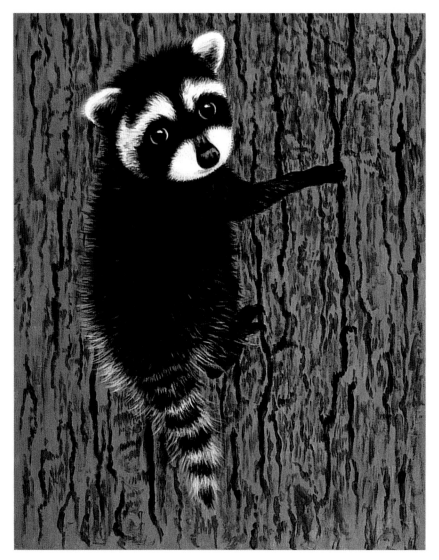

## STEP 5: **ADD MORE DETAIL**

Continue to paint detail in the tree bark with warm black.

With a no. 3 round and the blue shadow color, paint fur detail inside the ears. With separate no. 3 rounds for warm black and the buff color, paint long hairs along the outline of the back, tail, belly and haunch. Paint light-pressured, slightly curved strokes, blending the buff colored hairs where needed with warm black.

Mix a dark buff color with a portion of the buff color and Raw Sienna. Using the same stroke with the longer hairs, paint shorter hairs on the body and at the edges of the facial mask, blending with the warm black. Re-establish the dark outline of the body with warm black and a no. 3 round with strokes that follow the fur pattern.

**TIP**

When painting subtle hair detail in the darkest areas with the dark buff color, lightly wipe the brush on a paper towel after dipping it into the color. This will give you the correct amount of paint on the brush.

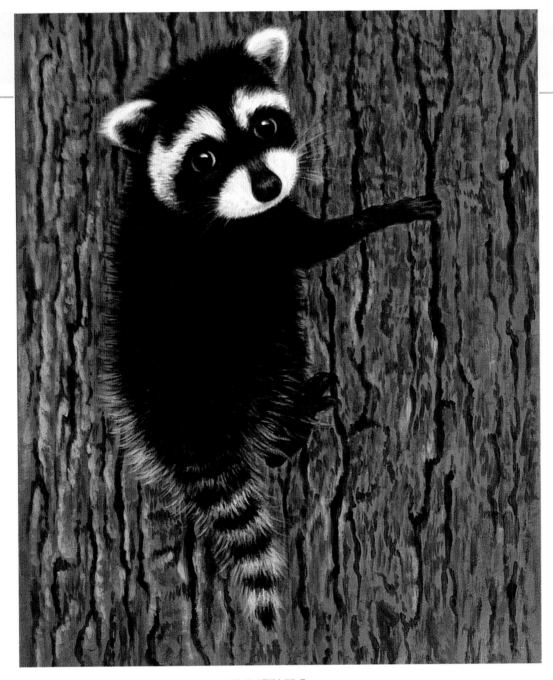

**Bright Eyed and Curious**
Acrylic on Gessobord
10" × 8" (25cm × 20cm)

## STEP 6: **PAINT THE FINISHING DETAILS**

Continue to paint dark buff detail in the black areas of the coat. Use a separate no. 3 round with warm black to tone down and blend. Mix a dark blue shadow color by adding more Ultramarine Blue and Burnt Umber to a portion of the blue shadow color. Paint detail around the eyes and on the nose and paw.

Reinforce and brighten the tail rings with a no. 3 round and the dark buff color. Add highlights to the tree bark with the buff color and a no. 10 round.

Using separate no. 3 rounds, add more detail to the muzzle with the blue shadow and buff colors. Blend with the white fur color. Lightly paint the whiskers with the white fur color and a no. 3 round, toning them down with warm black as needed. Paint highlights on the toes with the dark blue shadow color and a no. 3 round, blending with warm black.

Mix a mossy green for the tree trunk with Burnt Umber, Hooker's Green Permanent and Titanium White. Paint some moss on the bark with a no. 10 round, using the dry-brush technique.

# Opossum Baby

**Painting More Animal Friends**

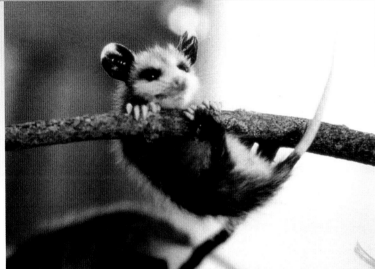

### REFERENCE

*Baby opossums are some of the cutest animals I've ever seen. This baby was one of five orphans that were about as small as mice when rescued. We successfully raised them all to adult size. Their favorite foods were grapes, oatmeal cookies and dry dog chow.*

Burnt Umber

Cadmium Red Medium

Naples Yellow

Titanium White

Ultramarine Blue

warm black

grayish brown

pink

dark pink shadow

green

shadowed fur color

light pink

warm white

gray

lichen green

### BRUSHES

Nos. 3, 10 rounds

No. 10 bright

## STEP 1: **ESTABLISH THE FORM**

Draw the baby opossum lightly in pencil, using a kneaded eraser to make corrections or lighten any lines that are too dark. With diluted Burnt Umber and a no. 10 round, paint the main lines and the form.

## STEP 2: **PAINT THE DARK VALUE COLORS**

Mix warm black with Burnt Umber and Ultramarine Blue. Paint the dark areas of the opossum and branch with a no. 10 round. Your strokes should follow the fur pattern.

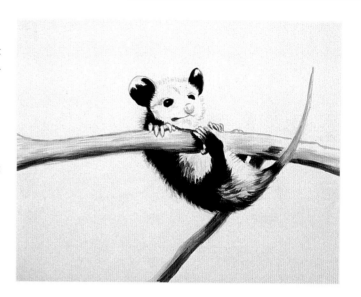

## STEP 3: **PAINT THE MIDDLE VALUE COLORS**

Mix grayish brown for the tree branch with Titanium White, Burnt Umber and Ultramarine Blue. Paint with a no. 10 round.

Mix pink for the opossum's belly and tail with Titanium White, Cadmium Red Medium and Burnt Umber. Paint with a no. 10 round.

Mix a dark pink shadow color with Titanium White, Cadmium Red Medium and a small amount of Burnt Umber. Paint shadows between the toes and dark nose detail with a no. 3 round.

Mix green for the background with Naples Yellow, Ultramarine Blue and Titanium White. Paint with a no. 10 bright, using dabbing strokes that allow the panel to show through in places. Use a no. 10 round to paint around the opossum's outline.

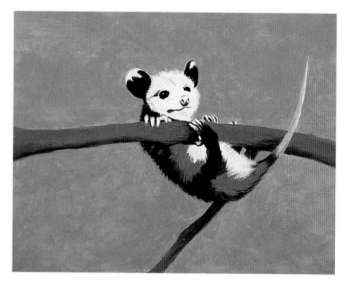

## STEP 4: **PAINT THE LIGHT VALUE COLORS**

Mix a shadowed fur color with Titanium White, Ultramarine Blue and Burnt Umber. Paint the shaded parts of the face, belly and tail with a no. 10 round. With another no. 10 round, paint the shadowed left edge of the tail with pink. Using separate no. 10 rounds for warm black, pink and the shadowed fur color, blend where the colors meet. Use brushstrokes that follow the fur pattern.

Mix a light pink for the nose and toes with Titanium White, Cadmium Red Medium and a touch of Naples Yellow. Paint with a no. 3 round. Use the dark pink shadow color and a separate no. 3 round to blend the edges. Use warm black for the shadows between the toes.

Add dark detail to the tree branch with warm black and a no. 10 round, using just a bit of paint with small, light-pressured strokes. Enlarge the left eye with warm black and a no. 3 round.

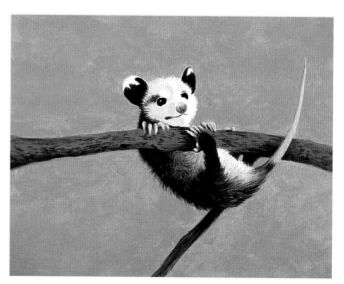

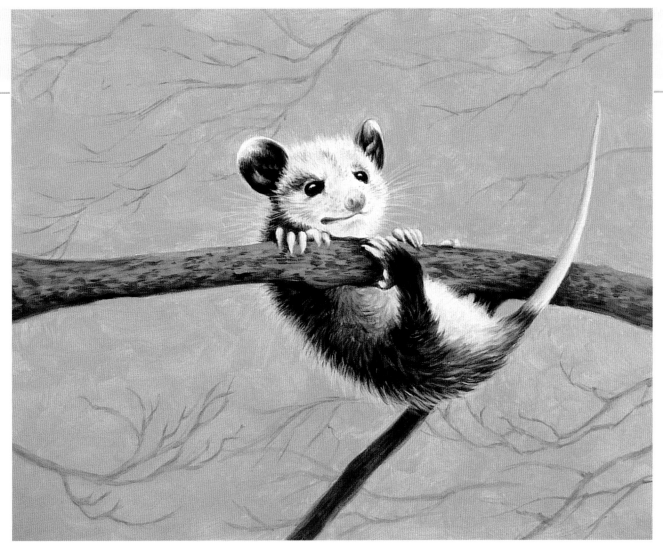

## STEP 5: **PAINT THE HIGHLIGHTS AND FINISHING DETAILS**

Mix warm white for fur highlights with Titanium White and a touch of Naples Yellow. Paint with a no. 10 round, using light, feathery strokes where the fur overlaps adjacent colors. Add detail to the nose with the same color.

Mix gray for the lighter parts of the fur and for the ears with a portion of warm black mixed with some of the shadowed fur color. Use a no. 3 round to paint detail on the face and ears, blending with a separate no. 3 round and the adjacent color.

Paint the fuzzy highlighted hair along the opossum's back with the shadowed fur color and a no. 3 round, blending the base of the hairs with warm black.

Mix a lichen green for the branch with a portion of the green background color mixed with Ultramarine Blue, Burnt Umber and Titanium White. Paint with a no. 10 round, using broken, horizontal strokes.

Paint the whiskers with warm white and a no. 3 round, using thin, light, slightly curving strokes. Paint a few strokes for the base of the whiskers with gray, blending with the adjacent color.

Mix the distant tree branch color with a portion of grayish brown mixed with more Burnt Umber and Ultramarine Blue. Paint thinly with a no. 3 round, using a little more water on the brush. Make your strokes light and sketchy.

**The Acrobat**
Acrylic on Gessobord
8" × 10" (20cm × 25cm)

**TIP**

If the tree branches look too dark, tone them down with the green background color. Paint thinly over the branches with a small amount of paint and a no. 10 round.

# WOLF PUP

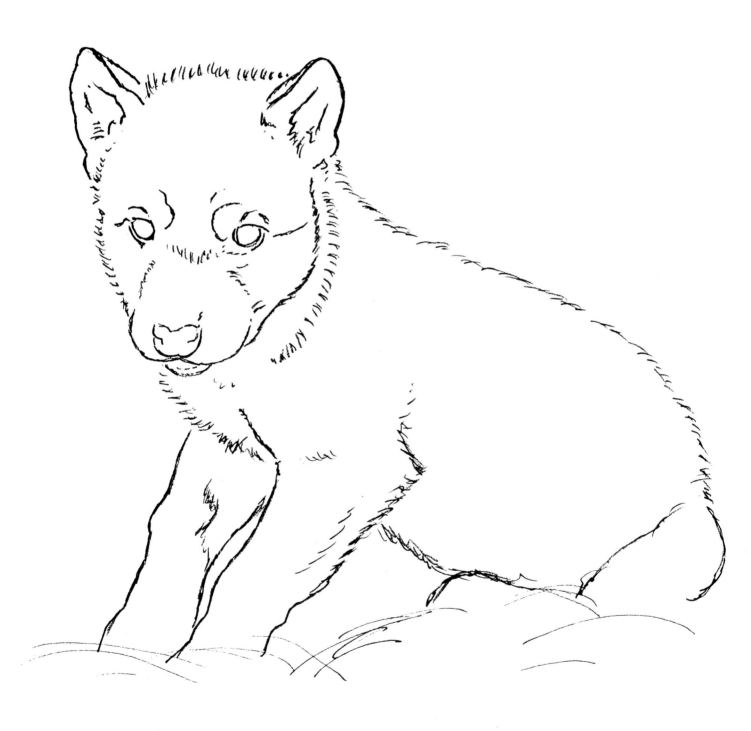

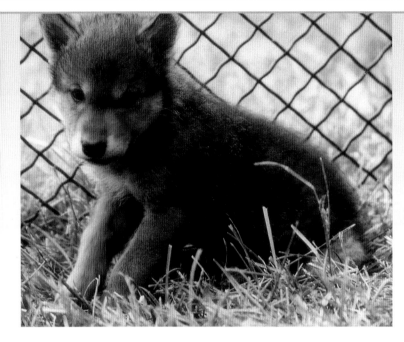

## REFERENCE

*On a trip to Wolf Park, a wolf behavior study center located in Battle Ground, Indiana, I was able to visit with and even hold several wolf puppies. They were quite innocent and endearing, but even at such a young age, the pups had a more alert and penetrating look than most domestic dog puppies.*

 Burnt Umber     warm black

 Cadmium Orange     dark brown

 Cadmium Red Medium     light brown

Hooker's Green Permanent     pink

Raw Sienna     dark green

Titanium White     blue eye

Ultramarine Blue     light tan

 medium green

Yellow Light Hansa     blue shadow

 medium brown

 whisker color

 light green

 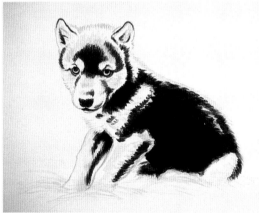

## STEP 1: **ESTABLISH THE FORM**

Lightly sketch the puppy onto the panel with a pencil, using a kneaded eraser for any corrections. With diluted Burnt Umber and a no. 10 round, paint the main lines and shading. For broader areas, use a no. 8 bright.

### TIP

To more easily see the main dark areas in your reference photo, squint your eyes. The dark areas will pop out.

## STEP 2: **PAINT THE DARK VALUE COLORS**

Mix warm black with Burnt Umber and Ultramarine Blue. Paint the broader areas with a no. 8 bright, using brushstrokes following the fur pattern. Use a no. 3 round for the eyes, nose and other details.

Mix dark brown with Burnt Umber and a bit of Ultramarine Blue. Use a no. 10 round.

### BRUSHES

Nos. 3, 10 rounds
Nos. 8, 10 brights

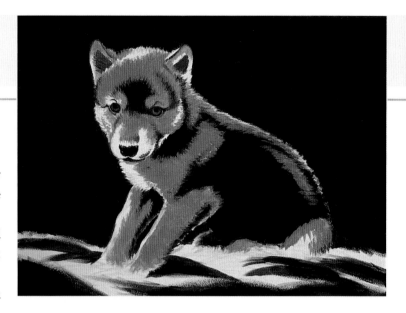

## STEP 3: **PAINT THE MIDDLE VALUE COLORS AND BEGIN THE BACKGROUND**

Mix light brown with Titanium White, Burnt Umber and Raw Sienna. Paint with a no. 8 bright, using strokes that follow the fur pattern. Switch to a no. 10 round for smaller areas.

Mix pink color for inside the ears with Cadmium Red Medium, Titanium White, Cadmium Orange and Burnt Umber. Paint with a no. 10 round.

Mix dark green for the background with Hooker's Green Permanent, Burnt Umber, Ultramarine Blue and a bit of Cadmium Orange. Paint dabbing, semicircular strokes with a no. 10 bright. Use a no. 10 round for around the puppy's outline. Paint shadowed areas in the foreground grass with a no. 10 bright, using sweeping strokes.

Mix a blue eye color with Ultramarine Blue, Titanium White and a bit of Burnt Umber. Paint with a no. 3 round.

## STEP 4: **PAINT THE LIGHT VALUE COLORS AND BEGIN THE DETAIL**

With separate no. 10 rounds for each color, blend where the dark brown meets the light brown. Add dark detail to the light brown areas with thin, light-pressured strokes. Add light brown detail to the dark areas using the same technique. Add detail to the light brown areas that adjoin the warm black areas using a no. 10 round for each color.

Mix light tan with Titanium White, Raw Sienna and Yellow Light Hansa. Paint the light areas of the puppy with a no. 10 round, using strokes that follow the fur pattern.

Mix medium green with Hooker's Green Permanent, Titanium White, Cadmium Orange and Yellow Light Hansa. Paint the lighter clumps of grass in sweeping strokes with a no. 10 bright.

Darken the pink inside the ears with a thin glaze of diluted Burnt Umber, using a no. 10 round.

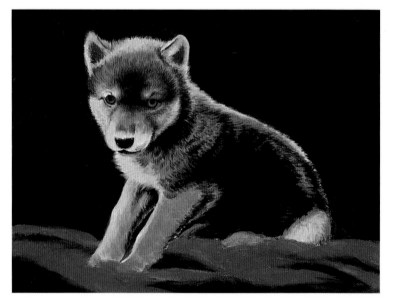

**TIP**

Varying the amount of water and paint on your brush can yield different effects. For subtle detail, use a small amount of paint with just enough water to make the paint flow. For highlighted areas that you want to stand out, use thicker paint and less water.

**TIP**

When painting the background, leave some areas with a thinner covering of paint, allowing some of the panel to show through. This will give it a sense of depth that could not be achieved with an opaque layer of paint.

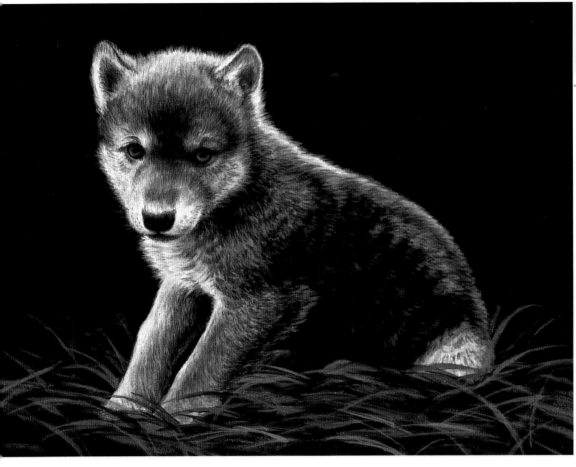

**The Young Alpha**
Acrylic on Gessobord
9" × 12" (23cm × 30cm)

**TIP**

For areas of finer detail, use a little more water with the paint, blotting the brush on a paper towel before applying.

## STEP 5: **PAINT MORE DETAIL AND FINISH**

Continue to add detail to the fur with separate no. 10 rounds for warm black, dark brown and light brown. Blend the edges where the light tan meets the adjacent color and to add highlights.

Mix a blue shadow color with Titanium White, Ultramarine Blue and Burnt Umber. Paint the lower muzzle and chin with a no. 10 round. Use the blue shadow color to add detail to the darkest areas of the fur, blending with warm black.

Refine the shape of the nose with warm black and a no. 3 round. With the blue shadow color and a no. 3 round, add detail to the nose and some color above the nose with small strokes. Blend with light brown. Refine the outline of the eyes and pupils with warm black and a no. 3 round. Blend with light brown. Add highlights to the eyes with the blue shadow and a no. 3 round, blending with the blue eye color and re-establishing the dark areas with warm black.

With a no. 3 round and light tan, paint light-pressured strokes from the outline of the puppy and overlapping the background. This will make the puppy look soft and fuzzy. Make the strokes from the head, back and chest longer and slightly curved, and from the legs and muzzle shorter and straighter. Use the blue shadow color to paint strokes from the left side of the face. Add a few strokes of the blue shadow color to the shadowed left side of the head and inside the ears.

Mix a medium brown with some of the light brown and dark brown to integrate the warm black parts of the puppy's body with the rest of the coat. Using a small amount of paint, make thin, light strokes next to or overlapping the blue shadow areas.

Mix a whisker color with some of the light brown and blue shadow colors. Paint the whisker nubs with a no. 3 round as small dots in rows on the muzzle, toning down and blending them with a separate no. 3 round and light tan.

Mix light green with a portion of medium green, Titanium White, Yellow Light Hansa and a touch of Cadmium Orange. With a no. 10 round, paint some strokes in the grass, and have some of them overlap the puppy. Add some strokes of medium brown to the grass.

# Paint Foal

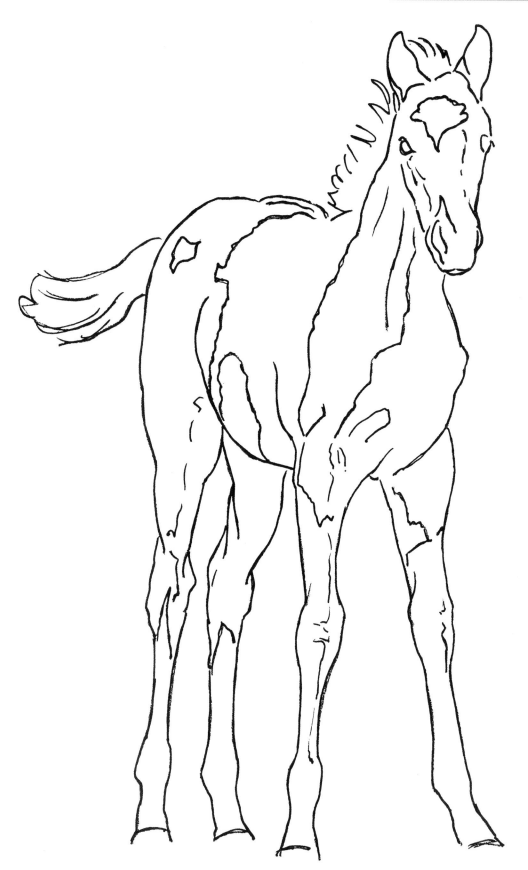

**Painting More Animal Friends**

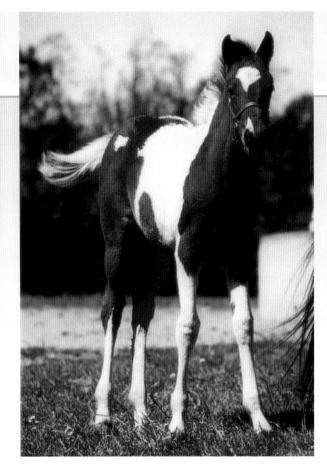

## REFERENCE

*I encountered this beautiful foal at a horse farm in central Kentucky. The farm raises thoroughbred race horses as well as paint horses, and many of the paint horses in the herd have thoroughbred ancestry. This foal embodies the elegant lines of the thoroughbred as well as the striking color patterns of a paint horse.*

## STEP 1: **ESTABLISH THE FORM**

Lightly sketch the foal onto your panel with a pencil, using a kneaded eraser for any corrections. With diluted Burnt Umber and a no. 10 round, paint the main lines and shading of the foal.

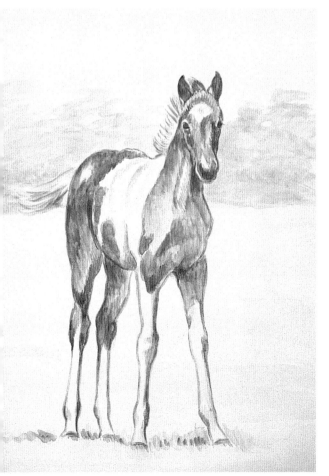

## PAINT COLORS    MIXTURES

Burnt Umber

dark brown

Cadmium Orange

warm black

Hooker's Green Permanent

dark slate gray

Raw Sienna

dark green

Red Oxide

red chestnut

Titanium White

blue shadow

Ultramarine Blue

misty blue

Yellow Light Hansa

green field

yellow-green

warm buff

warm white

reddish buff

pale blue sky

## BRUSHES

Nos. 3, 10 rounds

Nos. 4, 6, 8, 12 brights

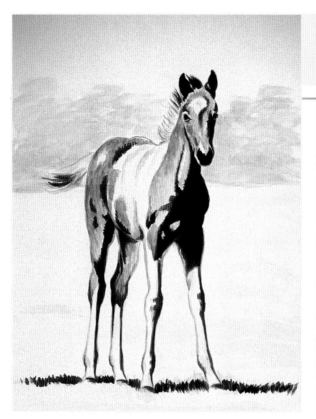

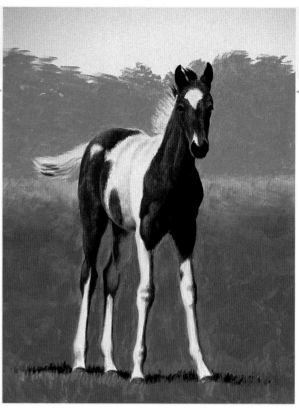

## STEP 2: PAINT THE DARK AND MIDDLE VALUE COLORS AND BEGIN THE BACKGROUND

Mix dark brown with Burnt Umber and Ultramarine Blue. Paint the darkest areas of the foal with a no. 4 bright; use a no. 10 round for the small areas.

Mix warm black with Burnt Umber and a lot of Ultramarine Blue. Paint the muzzle with a no. 10 round. Mix a dark slate gray with Burnt Umber, Ultramarine Blue and Titanium White. Paint the shadows on the hooves and on the white parts of the legs with a no. 10 round.

Mix a dark green grass color with Hooker's Green Permanent, Burnt Umber, Ultramarine Blue and a bit of Cadmium Orange. Paint the foal's shadow in the grass with a no. 8 bright, using dabbing, vertical strokes.

Mix a red chestnut color with Red Oxide, Cadmium Orange and Burnt Umber. Paint these areas of the horse with a no. 6 bright.

Mix a blue shadow color with Titanium White, Ultramarine Blue and a bit of Burnt Umber. Paint the hooves and the shadows on the legs, belly and muzzle with a no. 10 round.

Mix a misty blue for the background tree line with Titanium White, Ultramarine Blue and a bit of Burnt Umber, Cadmium Orange and Hooker's Green Permanent. Paint with a no. 12 bright, using dabbing strokes.

## STEP 3: PAINT THE LIGHT VALUES AND BACKGROUND

Mix a green field color with Titanium White, Hooker's Green Permanent, Cadmium Orange, Yellow Light Hansa, Burnt Umber and Ultramarine Blue. Use dabbing, vertical strokes with a no. 12 bright. Paint around the foal's outline with a no. 8 bright.

Mix yellow-green for the grass highlights with a portion of the green field color, Titanium White and Yellow Light Hansa. Paint at the line where the grass meets the trees with a no. 8 bright, blending with a no. 12 bright where it meets the field green.

Mix a warm buff color with Titanium White, Cadmium Orange, Yellow Light Hansa and Raw Sienna. Paint highlights on the red chestnut parts of the coat with a no. 4 bright. Paint highlights on the head and refine highlights on the body with a no. 10 round.

With a no. 3 round and dark brown, refine the shape of the eyes and head. Mix warm white with Titanium White and a touch of Yellow Light Hansa. Paint the white areas of the body with a no. 10 round, using dabbing strokes. Paint the mane and tail with flowing strokes.

Mix a reddish buff color with small amounts of the warm buff and red chestnut. Paint reflected light on the legs and shadowed part of the tail with a no. 10 round.

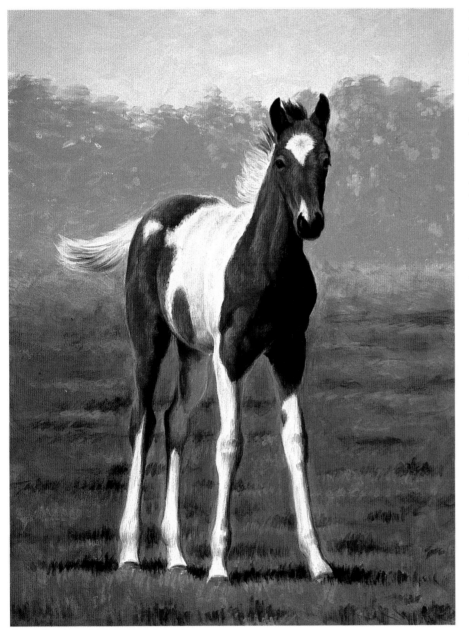

## STEP 4: **PAINT THE FINISHING DETAILS**

Mix a pale blue sky color with Titanium White, a bit of misty blue and a touch of Yellow Light Hansa. Paint the sky with a no. 12 bright using dabbing strokes. With a no. 6 bright and misty blue, re-establish the tops of the trees.

Paint shadows in the grass with dark green and a no. 8 bright, using uneven, vertical, dabbing strokes. With a no. 12 bright and a bit of dark green thinned with water, paint a glaze over the entire field to darken it.

Using no. 3 rounds, paint shadow detail on the white parts of the legs, body, tail and blaze on the forehead with the blue shadow and reddish buff colors. Blend with warm white and a no. 10 round. Add a few strokes of warm black to the mane and tail with a no. 3 round, blending with the adjacent color.

Paint highlights in the eyes and on the nostrils with a no. 3 round and the blue shadow, blending with the adjacent color.

With a no. 10 round and a small amount of yellow-green, add some strokes to the grass. Paint a few very light strokes of the red chestnut in the grass to integrate the foal with the background. Add a few small dabs of the blue sky color in the trees to show light coming through the open places.

Add some detail to the dark chest by lightly painting the chest muscles with red chestnut and a no. 10 round.

**Red, White and Cute**
Acrylic on Gessobord
12" × 9" (30cm × 23cm)

**TIP**

Don't hesitate to manipulate the background in order to enhance the main subject. In this case, darkening the field will allow the highlights on the foal to stand out more.

# Bison Calf

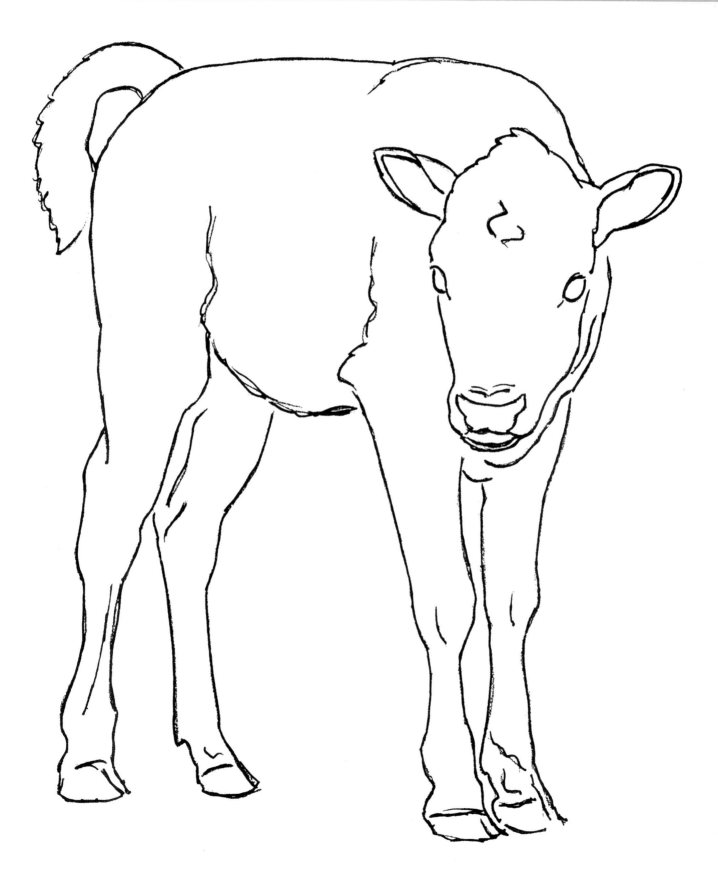

**Painting More Animal Friends**

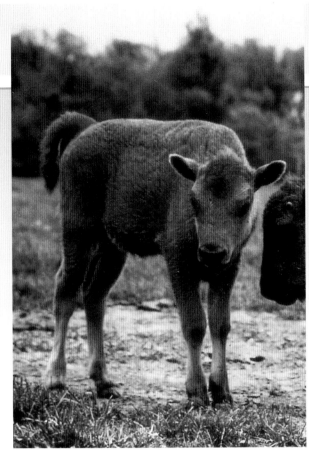

## REFERENCE

*This bison calf was born at Wolf Park in Battle Ground, Indiana, where, in addition to the wolves that live there, a small herd of bison resides. I found the bison calf to be quite similar to domestic calves in some ways, but you can definitely see that this one will grow up to be a bison. As with all young animals, this baby was very cute and appealing.*

## STEP 1: **ESTABLISH THE FORM**

Sketch the calf lightly onto your panel with a pencil, using a kneaded eraser for any corrections. With a no. 10 round and diluted Burnt Umber, paint the main lines and shading of the calf.

**TIP**

If your Burnt Umber wash is too dark, lightly wipe your brush on a paper towel before applying to your painting.

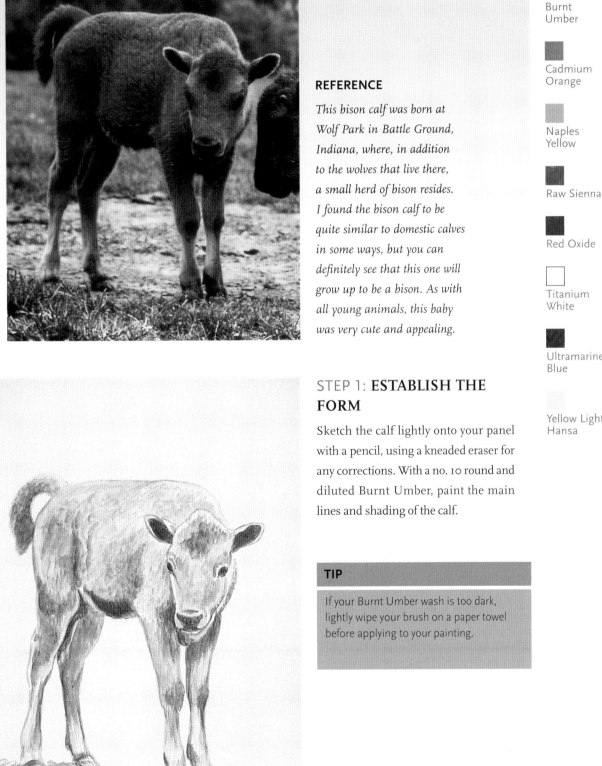

## PAINT COLORS    MIXTURES

 Burnt Umber     warm black

 Cadmium Orange     warm buff

Naples Yellow     blue-green

 Raw Sienna     green grass

 Red Oxide     grass shadow

Titanium White     dark reddish brown

 Ultramarine Blue     blue shadow

Yellow Light Hansa    dusty blue sky

warm cream

 gray

 light reddish brown

 reflected green

 warm brown

### BRUSHES

Nos. 3, 10 rounds

Nos. 2, 6, 8, 10 brights

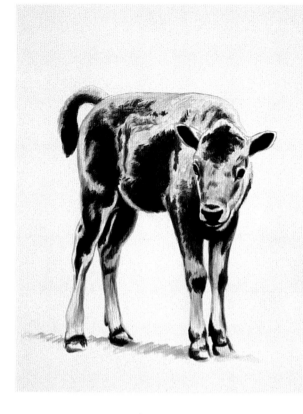

## STEP 2: **PAINT THE DARK VALUE COLORS**

Mix warm black with Burnt Umber and Ultramarine Blue. Paint the darkest areas with a no. 2 bright. For good coverage, add a second coat when dry. Use a no. 3 round to paint the eyes and nose.

Mix a dark reddish brown with Red Oxide, Burnt Umber and Ultramarine Blue. Paint the forehead, body, legs and tail with a no. 6 bright, blending where the dark reddish brown meets the warm black with a separate no. 6 bright. Use dabbing strokes for the woolly coat.

## STEP 3: **PAINT THE MIDDLE VALUE COLORS AND BEGIN THE BACKGROUND**

Mix a warm buff color for the coat with Titanium White, Raw Sienna, Naples Yellow and Cadmium Orange. To create the woolly coat texture, use a no. 8 bright and dabbing strokes.

Mix blue-green for the background trees with Titanium White, Ultramarine Blue, Naples Yellow and Cadmium Orange. Paint dabbing strokes with a no. 10 bright; switch to a no. 10 round for around the ears and tail.

Mix a green grass color with Titanium White, Ultramarine Blue, Naples Yellow, Yellow Light Hansa and a small amount of Cadmium Orange. Paint the grass with a no. 10 bright, using dabbing, horizontal strokes. Start from the tree line and work downwards.

Mix a grass shadow color with a portion of the green grass color mixed with more Ultramarine Blue, Cadmium Orange and Yellow Light Hansa, plus some Burnt Umber. Paint a shadow under the calf and more grass shadows with a no. 8 bright, using dabbing, vertical strokes. Add more of the green grass color as before, blending where it meets the grass shadow. Use a separate no. 10 bright for each color.

Add detail to the warm buff areas of the calf's woolly coat with the dark reddish brown from step 2 and a no. 6 bright. Using the dry-brush technique, make dabbing strokes for the dark detail and to blend the edges of the large dark shadowed areas. With a no. 8 bright and warm buff, blend and tone down as needed. Use no. 10 rounds for the smaller detail.

Mix a blue shadow color with Titanium White, Ultramarine Blue and Raw Sienna. Paint the shadowed areas of the belly, legs, chin and hooves with a no. 10 round, blending with a separate no. 10 round and the adjacent color.

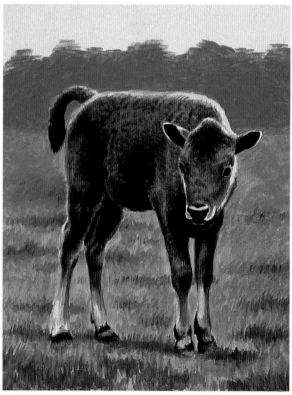

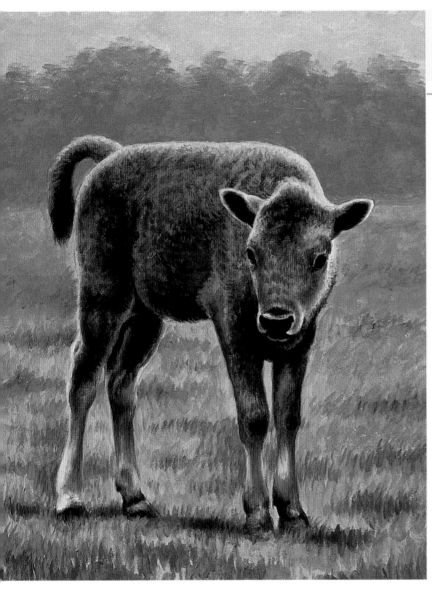

**Buffalo Baby**
Acrylic on Gessobord
12" × 9" (30cm × 23cm)

## STEP 4: **PAINT THE FINISHING DETAILS**

Mix a dusty blue sky color with Titanium White, Ultramarine Blue and a touch of Naples Yellow. Paint dabbing strokes with a no. 10 bright. Blend the tops of the trees with blue-green and no. 10 round while the paint is still wet.

Mix a warm cream highlight color for the calf's coat with Titanium White, Naples Yellow and a touch of Yellow Light Hansa. Paint highlights with a no. 10 round, blending where they meet the adjacent color, using a separate no. 10 round. Switch to no. 3 rounds for small details.

Refine the shape of the nose with warm black and a no. 3 round. Add detail to the dark areas of the coat with a no. 3 round and warm buff. Blend and tone down as needed with a separate no. 3 round and reddish brown.

Add more shadow detail to the grass with the grass shadow color and a no. 8 bright, blending with the green grass color.

Create a gray for the lower legs by mixing a small portion of the blue shadow color with warm black. Paint with a no. 10 round, blending with the adjacent colors.

Mix a light reddish brown with a small portion of dark reddish brown and a bit of warm buff. Paint shadows on the lower legs, blending with the adjacent color.

Mix a reflected green color with a bit of the grass shadow color mixed with a bit of the green grass color. With a no. 10 round, lightly paint a few strokes on the legs and belly, blending as needed with the adjacent color.

Darken the calf's shadow on the ground with a bit of dark reddish brown and a no. 6 bright. Blend with a separate brush and the grass shadow color.

Mix warm brown with Cadmium Orange, Red Oxide, Burnt Umber and a bit of Titanium White. Use a no. 3 round to paint a thin arc along the outer edge of the left eye, leaving warm black on either side. Blend the edges with warm black.

With separate no. 3 rounds for the warm cream and warm buff colors, paint small strokes along the dark edges of the ears to soften them.

**TIP**

In order to make the almost white parts of the lower legs stand out, manipulate the background by adding shadows to darken it.

**TIP**

Adding some of the background color to the animal helps integrate the main subject with the background. Add some of the animal's color to the background as well.

# Fox Cub

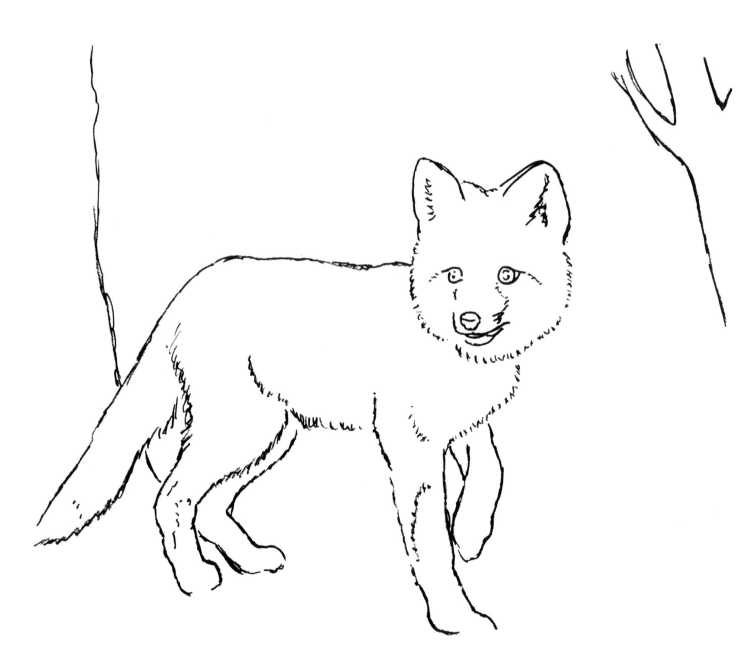

**Painting More Animal Friends**

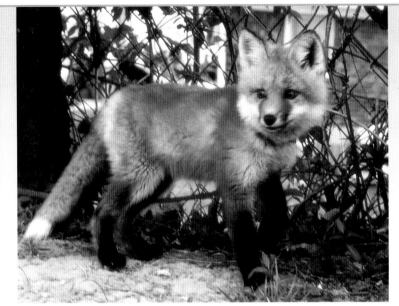

## REFERENCE

*This pretty little red fox cub had been orphaned and was in the care of a wildlife rehabilitator. I was impressed by the alertness and intelligence in the cub's eyes as well as the quickness and agility present in such a young animal. I imagined how the fox would look after he had been released into the woods.*

### PAINT COLORS

Burnt Sienna

Burnt Umber

Cadmium Orange

Hooker's Green Permanent

Naples Yellow

Raw Sienna

Titanium White

Ultramarine Blue

Yellow Light Hansa

### MIXTURES

 black

 rufous

 blue shadow

 warm gray

 earth green

 brown leaf

blonde highlight

warm white

 warm brown eye color

 dark green

 green highlight

### BRUSHES

Nos. 3, 10 rounds

No. 8, 10 brights

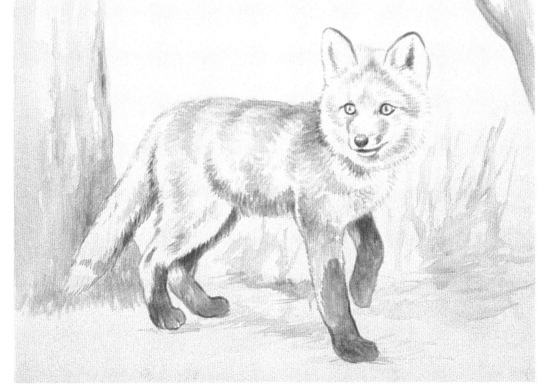

## STEP 1: ESTABLISH THE FORM

Lightly draw the fox cub onto the panel with a pencil, using a kneaded eraser to make corrections or lighten lines. Use diluted Burnt Umber and a no. 10 round to establish the main lines and the form.

## STEP 2: **PAINT THE DARK VALUE COLORS**

Mix a black for the cub's darkest parts—legs, nose, mouth and the outline around the eyes and ears—with Burnt Umber and Ultramarine Blue. Paint with a no. 10 round, switching to a no. 3 round for the face and ears.

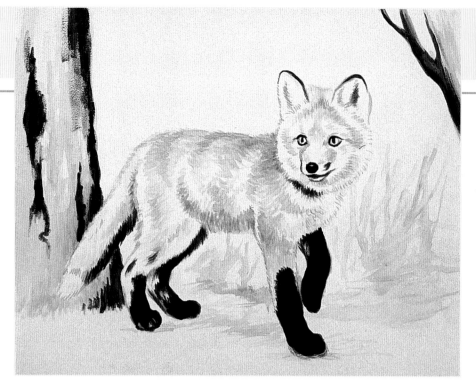

## STEP 3: **PAINT THE MIDDLE VALUE COLORS**

Mix a rufous color with Burnt Sienna, Cadmium Orange and Titanium White. Paint the fur with a no. 10 round, using strokes that follow the hair pattern.

Mix a blue shadow color with Titanium White, Ultramarine Blue and Burnt Umber. Paint the shadows in the ears, under the neck and chest ruff and on the legs with a no. 10 round.

Mix a warm gray for the tree trunk with Titanium White, Burnt Umber and Ultramarine Blue. Paint vertical strokes with a no. 10 round.

**TIP**

If you find it hard to see where the middle value colors are in your reference photo, squint your eyes. This will eliminate detail and cause the values to stand out.

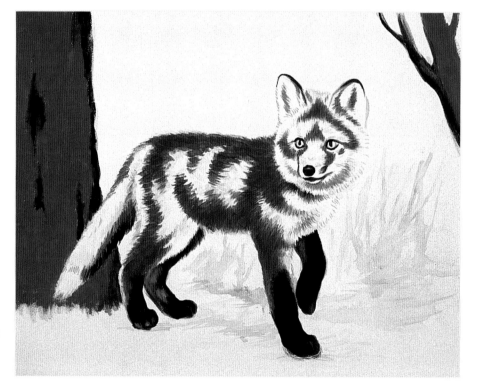

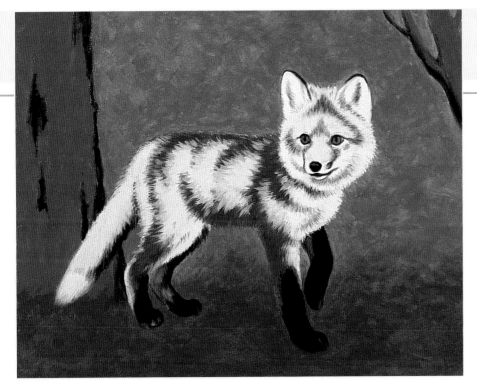

## STEP 4: **PAINT LIGHT VALUE COLORS AND BACKGROUND**

Mix an earth green color with Naples Yellow and Ultramarine Blue. Paint the background with a no. 10 bright. Switch to a no. 10 round for around the cub's outline. Use dabbing, semi-circular strokes.

Mix a brown leaf color for the ground with Titanium White, Raw Sienna and Burnt Umber. Paint with a no. 10 bright, using dabbing, horizontal strokes. Switch to a no. 10 round for around the cub's legs and feet. Blend into the green background using the dry-brush technique.

Mix a blonde highlight color with Titanium White and small amounts of Yellow Light Hansa and Cadmium Orange. With a no. 10 round, use tuft-shaped strokes following the fur pattern.

Mix a warm white for the ears, ruff, chest and tip of the tail with Titanium White and a touch of Yellow Light Hansa. Paint with a no. 10 round.

Mix a warm brown eye color with Cadmium Orange, Raw Sienna and Titanium White. Paint the eye with a no. 3 round. Use some of the blue shadow color for the corner of the left eye.

## STEP 5: **ADD DETAIL**

Paint a thin glaze over the blonde areas of the coat with rufous and water, using a no. 10 round. Add detail to the coat with a no. 10 round and rufous. Add dark detail with black, blending with rufous.

Use the dry-brush technique to paint texture on the tree trunk using black and a no. 8 bright. Use black and a no. 10 round for fallen leaf detail on the ground.

Blend into the earth green background color with smaller, lighter value detail.

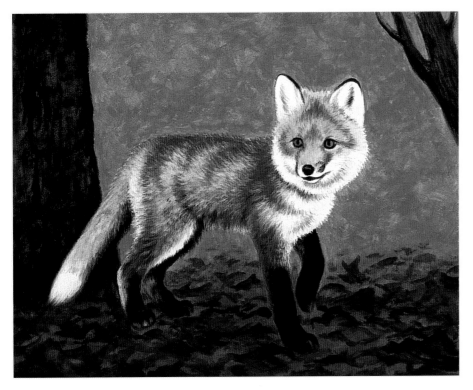

**TIP**

By varying the amount of water you use on your brush, you can control the darkness of the details you are painting.

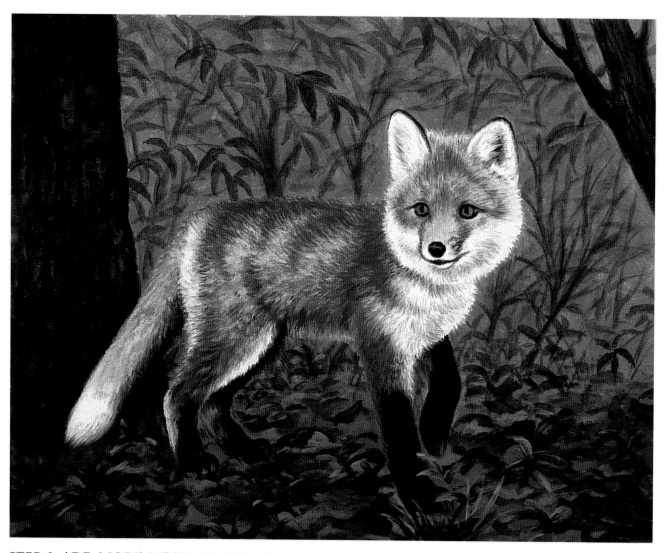

## STEP 6: **ADD MORE DETAIL TO THE CUB AND BACKGROUND**

Continue to add detail to the fur with no. 3 rounds, blending with the adjacent color or with a clean, damp brush. Add blue shadow color detail to the white areas of the fur, blending with warm white. For lighter value detail, add some Titanium White to the blue shadow color.

Mix a leaf highlight color with warm white and some of the brown leaf color. Paint highlights with a no. 10 round.

Mix dark green with Hooker's Green Permanent, Cadmium Orange, Burnt Umber and Ultramarine Blue. Use a no. 10 round on the small woodland plants. Mix a green highlight color with a portion of earth green and Titanium White and Yellow Light Hansa. Paint highlights with a no. 10 round. Paint some tree leaves in the background with dark green thinned with a small amount of water. Paint some of the leaves with less paint to create a sense of distance. With diluted black, paint a few saplings in the background.

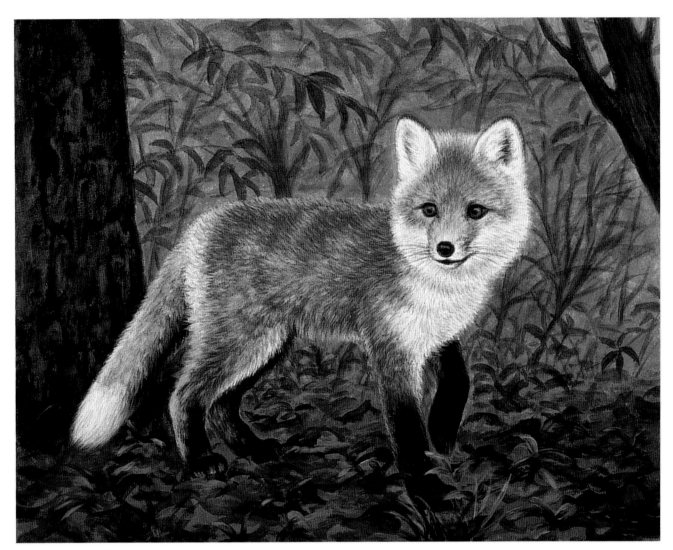

## STEP 7: **PAINT THE FINISHING DETAILS**

**The Young Fox**
Acrylic on Gessobord
8"× 10" (20cm × 25cm)

With a no. 3 round and the blonde highlight color, continue to add detail to the fur. Soften the outline of the ears with a small amount of earth green and a no. 3 round. Paint some dark detail in the tail with black and a no. 3 round. Add lighter detail with the blonde highlight color, then blend and soften with warm white. Add some very light strokes of rufous to the blue shadowed areas of the ruff, chest and tail.

Use a no. 10 round to restore color and integrate the reddish parts of the coat with a thin glaze of rufous and water. Re-establish highlights as needed.

Using black, the eye color and separate no. 3 rounds, blend where the dark pupils and the outline of the eye meet the warm brown eye color. Mix a highlight color for the eye with Titanium White and the blue shadow. Use a no. 3 round. Paint the corner of the left eye with blue shadow color.

Soften the outline of the nose with the blue shadow color and a no. 3 round. Paint the whiskers with diluted black and a no. 3 round, using light, feathery strokes. Tone down as needed with warm white.

To help integrate the fox with the background, add some touches of rufous with a no. 10 round using small, dabbing strokes on randomly selected lighter value leaves.

# PART THREE

# Exotic Animals

Animals are considered exotic when they are very different from the animals you are used to seeing. Animals from Africa, India or Madagascar seem exotic to me, while a raccoon or opossum might seem exotic to someone from one of these countries!

What compels me to paint these animals is their beauty, character and striking coat patterns. The elephant's wrinkled skin and trunk make it a very distinctive subject, while the white tiger cub's stripes and blue eyes, the giraffe's long neck and spots, the zebra foal's bold stripes and the lemur's large, luminous eyes are also fascinating and a lot of fun to paint.

Visit zoos and wild animal parks with your sketchbook and camera to familiarize yourself with animals from other parts of the world. Once you become accustomed to their different characteristics, you will realize that the same techniques used to paint animals that are more familiar to you are used to paint exotic animals as well.

  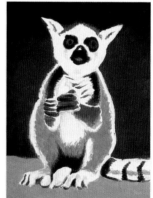 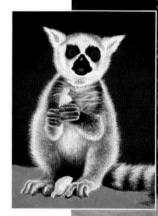

**Afternoon Snack**
Acrylic on Gessobord
9" × 12" (23cm × 30cm)

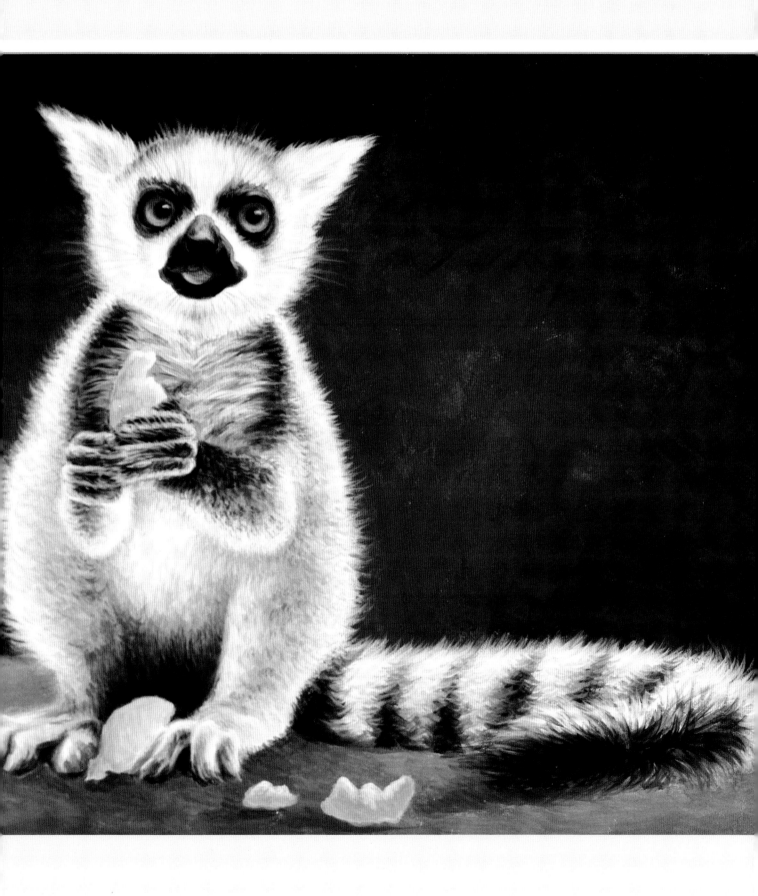

# ELEPHANT

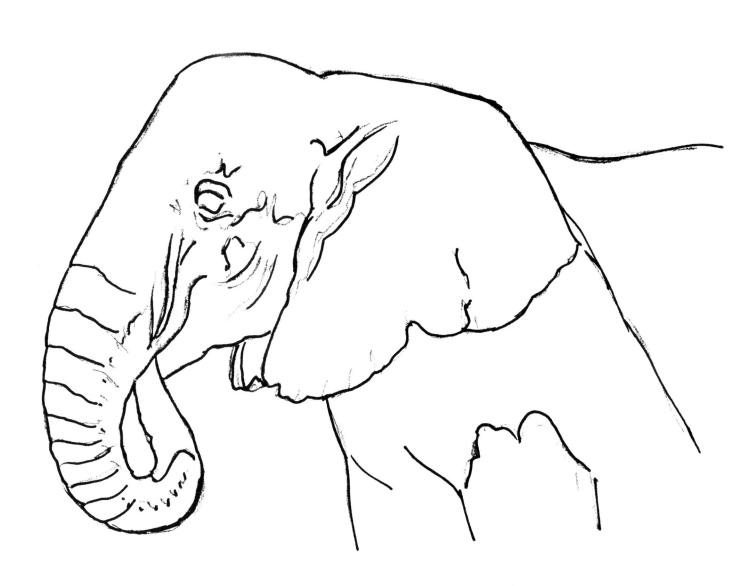

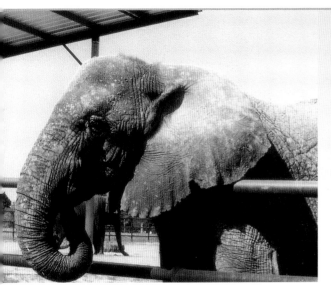

## PAINT COLORS

 Burnt Sienna

 Burnt Umber

 Cadmium Orange

 Hooker's Green Permanent

 Naples Yellow

 Raw Sienna

 Titanium White

 Ultramarine Blue

## MIXTURES

 dark brown

 medium brown

 reddish

 green tree

 blue sky

light blue sky

 wheaten

 brownish gray

 light gray

 highlight

 shadow detail

 warm brown eye color

 blue-gray eyelash color

 tree highlight

 dry grass shadow

## BRUSHES

Nos. 3, 10 rounds

Nos. 8, 10, 12 brights

### REFERENCE

*I met Conga at the Black Beauty Ranch in Athens, Texas, a sanctuary for abused and abandoned animals created by animal rescue group The Fund for Animals. Female African elephants (unlike female Indian elephants) have tusks, but Conga had lost her left one at some point. While we were visiting, Conga played a game of catch with us through the fence: we tossed a stick and Conga picked it up and tossed it back.*

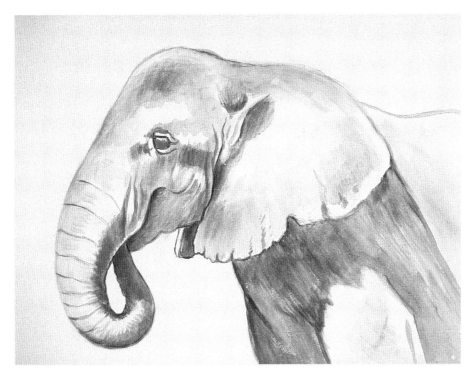

## STEP 1: **ESTABLISH THE FORM**

Lightly sketch the elephant onto the panel with a pencil, using a kneaded eraser to make corrections or lighten lines. With a no. 10 round and diluted Burnt Umber, paint the basic lines and shading. Use a no. 10 bright for the broad areas.

## STEP 2: PAINT THE DARK VALUE COLORS

Create a dark brown with Burnt Umber, Burnt Sienna and Ultramarine Blue. Paint with a no. 10 round, switching to a no. 10 bright for broad areas. Use brushstrokes that follow the elephant's contours.

## STEP 3: PAINT THE MIDDLE VALUE COLORS

Mix medium brown for the middle value shadows with Titanium White, Raw Sienna, Burnt Umber and a small amount of Ultramarine Blue. Paint with a no. 10 round, using a no. 8 bright for the broader areas. Mix a reddish color for the top of the head with a portion of medium brown mixed with Titanium White, Burnt Sienna and Cadmium Orange. Use dabbing strokes with a no. 8 bright.

Mix a green tree color for the distant tree line with Hooker's Green Permanent, Cadmium Orange, Titanium White, Burnt Umber and Ultramarine Blue. Paint dabbing, horizontal strokes with a no. 10 round.

Mix a blue sky color with Titanium White, Ultramarine Blue and Naples Yellow. Paint dabbing strokes with a no. 12 bright. Mix light blue for the horizon with a portion of the blue sky color and Titanium White. Paint with a no. 10 bright, blending where it meets the blue sky color. Use a no. 3 round for the sky underneath the elephant's chin. Use a no. 10 round and the green tree color to blend where the tops of the trees meet the sky.

Mix a wheaten color for the dry grass with Titanium White, Raw Sienna and Naples Yellow. Paint dabbing strokes with a no. 10 bright; switch to a no. 10 round for around the elephant's outline. Use the green tree color to blend where it meets the wheaten.

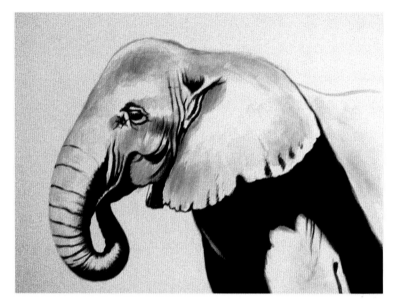

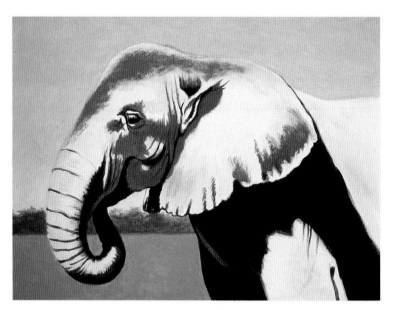

**TIP**

Although I saw the elephant in the U.S., I wanted it to appear as though she were in her native Africa. I referred to a book about elephants to see how trees in Africa differed from those in the reference photo. They were more angular, with horizontal rather than rounded clumps of foliage.

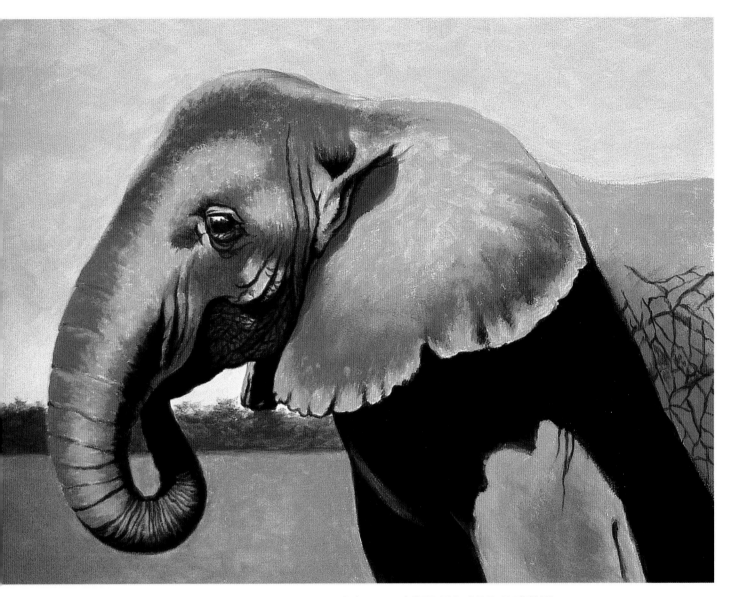

## STEP 4: **PAINT THE LIGHTER VALUE COLORS AND BEGIN TO ADD DETAIL**

Mix a brownish gray for the elephant's hide with Titanium White, Raw Sienna, Ultramarine Blue and Burnt Umber. Mix a lighter gray by adding more Titanium White to a portion of brownish gray. Paint the brownish gray areas with a no. 10 bright, using a no. 10 round for the smaller areas. Use the same size brushes to paint the lighter gray areas. Blend where the two colors meet, using a separate brush for each color.

With dark brown, blend where the shadowed areas meet the adjacent colors. Begin to paint the thin line detail in the elephant's hide using a no. 10 round and the reddish color.

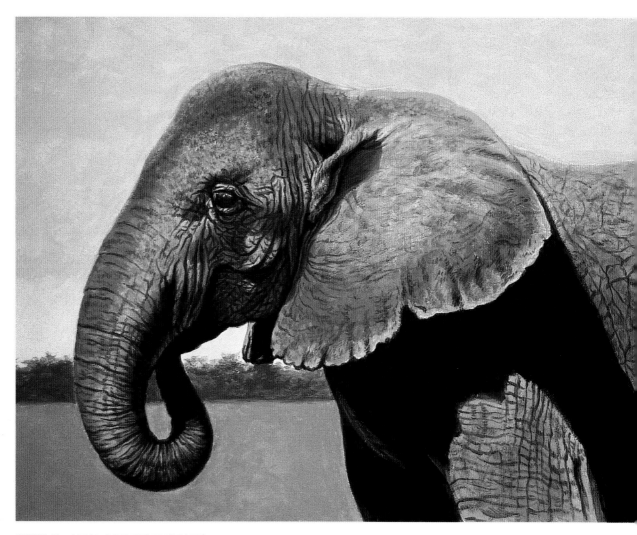

## STEP 5: **ADD MORE DETAIL**

Continue to paint detail on the elephant's hide. For lighter tone lines, use less paint. Darken the middle value shadowed areas as needed with dark brown and a no. 10 round. Paint over these areas with very light parallel strokes.

Use the reddish color to paint pebbly detail in the lighter areas of the elephant. Use the dry-brush technique with a no. 10 round to paint small, dabbing strokes. For broader areas such as the ears, leg and back, use a no. 8 bright.

### TIP

If any lines look too dark, soften them by painting over them lightly with the underlying color.

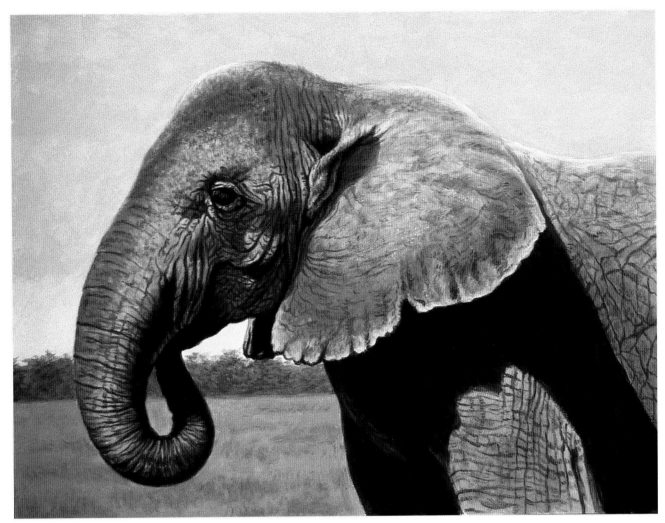

**Conga**
Acrylic on Gessobord
8" × 10" (20cm × 25cm)

## STEP 6: **PAINT THE FINISHING DETAILS**

Mix a highlight color with Titanium White and a small amount of Naples Yellow. Paint highlights on the top of the head, ear and back. Paint highlights on the lower edge of the ear.

Mix a shadow detail color with a portion of medium brown and dark brown. Lightly paint detail in the dark shadowed areas with a no. 10 round. When dry, use a small amount of dark brown and a no. 3 round to lightly paint over and tone down the detail.

Mix the warm brown eye color with Burnt Sienna, Burnt Umber and small amounts of Cadmium Orange and Titanium White. Paint a small arc in the lower half of the eye with a no. 3 round, blending with a separate brush and dark brown.

Mix the blue-gray eyelash color with a bit of the blue sky color mixed with medium brown. Paint the eyelashes with a no. 3 round, blending with dark brown.

Mix a tree highlight color with a portion of the green tree color, Titanium White and Naples Yellow. Lightly paint detail with a no. 10 round, using quick, dabbing strokes.

Mix a dry grass shadow color with Titanium White, Burnt Umber and Raw Sienna. Use a small amount of paint on a no. 8 bright for the shadows, painting dabbing strokes.

**TIP**

Animal eyes, especially elephant eyes, often do not show up well in photos. Take close-up photos of the animal's eyes, or use a picture from your photo file or a book to see the detail.

# GIRAFFE

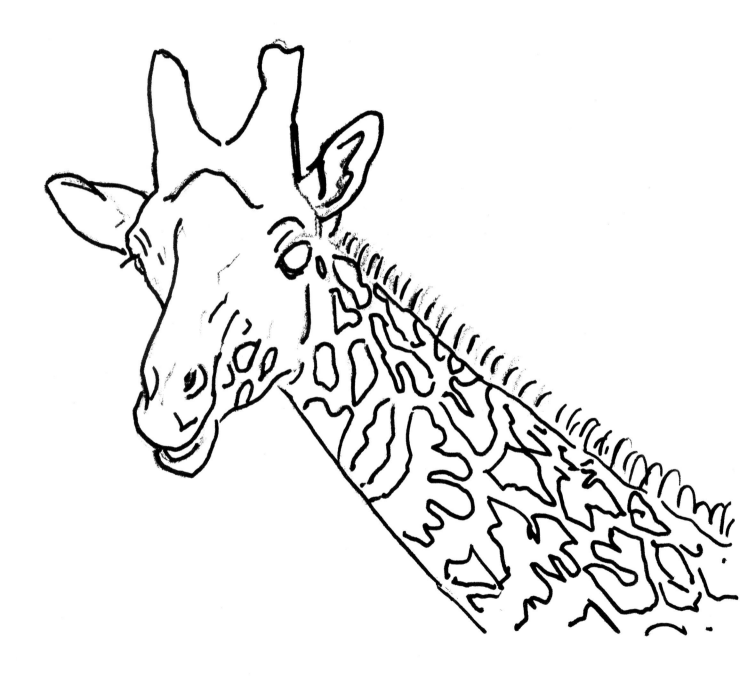

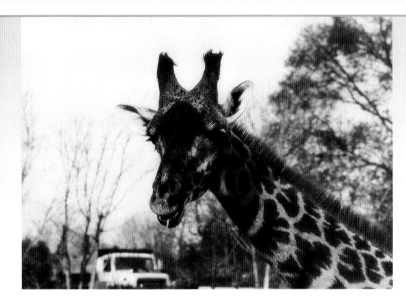

## PAINT COLORS

 Burnt Sienna

Burnt Umber

Cadmium Orange

Naples Yellow

Raw Sienna

Titanium White

Ultramarine Blue

## MIXTURES

 warm black

 dark brown

 reddish brown

 buff

 dark buff

 blue sky

light blue sky

off-white

 shadow color

ear hair color

 whisker color

### REFERENCE

*I have always been fascinated by giraffes. As a child, on my first trip to a zoo, I remember that the first animal I wanted to see was a giraffe. I was not disappointed! I observed this giraffe at the Cincinnati Zoo.*

### BRUSHES

Nos. 3, 10 rounds

No. 12 bright

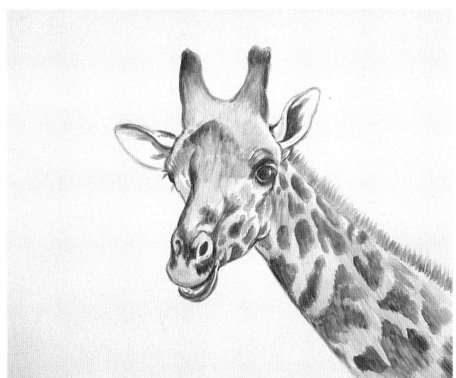

## STEP 1: **ESTABLISH THE FORM**

Lightly sketch the giraffe onto your panel in pencil, using a kneaded eraser to make corrections or lighten lines. With a no. 10 round and diluted Burnt Umber, paint the main lines and shaded areas.

## STEP 2: **PAINT THE DARK VALUE COLORS**

Mix warm black with Burnt Umber and Ultramarine Blue. With a no. 10 round, paint the tops of the horns, the lower lip and the shadows inside the ears. Mix dark brown color with Burnt Umber, Burnt Sienna and Ultramarine Blue. With a no. 10 round, paint the eyes, the facial markings, the spots in shadow on the neck and the base of the mane. For good, dark coverage, paint more layers after the first layer is dry.

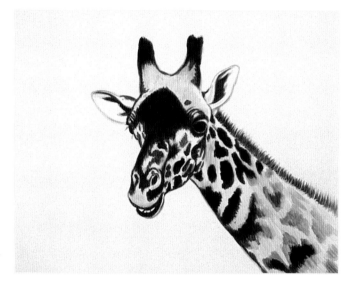

## STEP 3: **PAINT THE MIDDLE VALUE COLORS**

Mix reddish brown for the spots that are not in shadow with Burnt Umber, Burnt Sienna, Cadmium Orange and a small amount of Ultramarine Blue. Paint with a no. 10 round.

Mix a buff color with Titanium White, Naples Yellow, Cadmium Orange and Raw Sienna. Mix a dark buff color with the same colors, plus Burnt Sienna and Raw Sienna. Paint the darker areas of the coat between the spots with dark buff, and the lighter areas with buff. Use a no. 10 round to paint strokes that follow the hair pattern.

Mix a blue sky color with Titanium White, Ultramarine Blue and a touch of Cadmium Orange. Paint dabbing strokes with a no. 12 bright; switch to a no. 10 round for around the giraffe's outline. Mix a lighter blue sky color with a portion of blue sky and Titanium White. Paint the lower quarter of the sky, blending with a separate brush and the blue sky color.

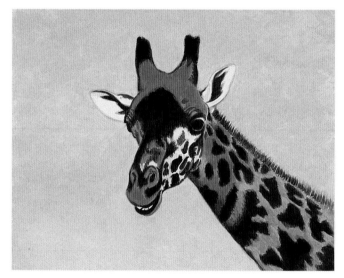

## STEP 4: **PAINT THE LIGHT VALUE COLORS AND ADD DETAIL**

Mix an off-white for the ear, face and forehead with Titanium White and a small amount of Raw Sienna. Paint with a no. 10 round. Paint the teeth with a no. 3 round.

Paint detail in the ears with separate no. 3 rounds and warm black, reddish brown and off-white, blending where the colors meet.

Mix a shadow color with Titanium White, Raw Sienna and a bit of Ultramarine Blue. Paint the lighter areas of the head with a no. 10 round, blending with a separate brush and the adjacent color.

With dark brown and a no. 3 round, paint detail in the upper forehead, muzzle and horns with small, thin strokes. Use the buff color and a no. 3 round to paint detail in the dark part of the forehead, blending with dark brown and a separate no. 3 round.

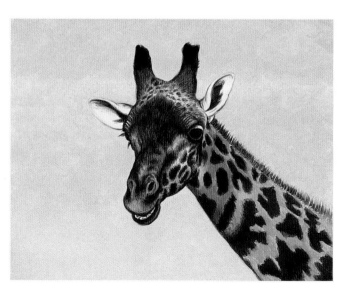

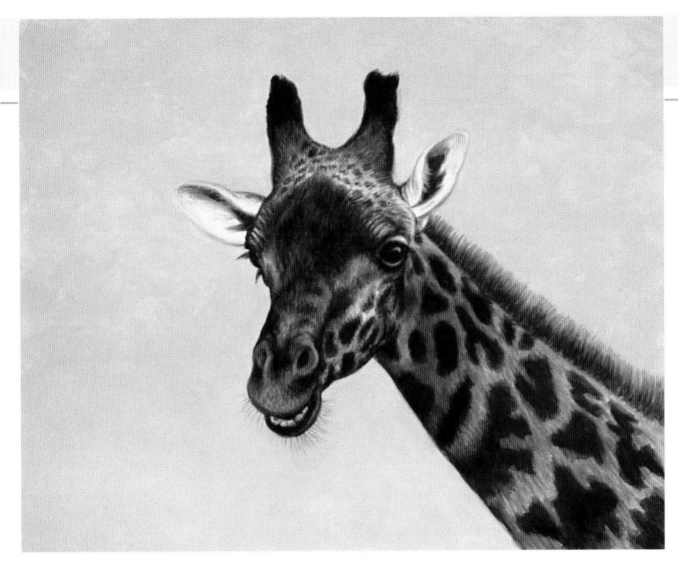

**Elegance**
Acrylic on Gessobord
9" × 12" (23cm × 30cm)

## STEP 5: **PAINT THE FINISHING DETAILS**

Integrate the spots on the neck with the buff base color by feathering the edges of the spots with a no. 10 round and dark brown in the shadowed areas, and reddish brown in the more lighted areas. Use a small amount of paint with light-pressured strokes. Add detail to the buff and dark buff areas using the spot colors (dark brown and reddish brown) with small, light strokes. Use the same technique to integrate spots on the giraffe's head.

Lengthen the mane with a no. 10 round and thin strokes of reddish brown. Add some darker strokes with dark brown. Highlight the upper edge of the mane and reinforce the top line of the neck with buff.

Paint a highlight in the eye with the light blue sky color, blending the edges with a separate brush and dark brown. Reinforce the lower lid with dark buff, then use buff to carefully highlight the lowest part of the lid.

Paint detail on the muzzle with the reddish color and a no. 3 round, using short strokes. Tone down the teeth with buff, blending with dark brown. Paint a few hairs in the ears that overlap the shadows in the ears with a no. 3 round and a bit of off-white mixed with a bit of the shadow color.

Mix a whisker color with dark brown and the blue sky color. Paint lightly with a no. 3 round, toning down as needed with a separate brush and the blue sky color.

**TIP**

For subtle details, often a combination of two of your mixed colors is best. When only a small amount is needed, use your brush to mix the color variation right on your palette.

# White Tiger Cub

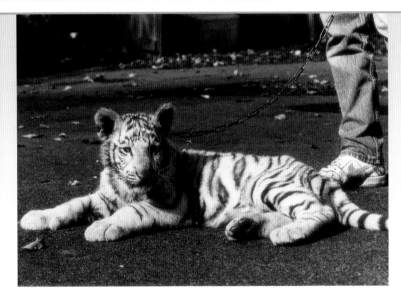

## REFERENCE

*The Cincinnati Zoo has a very successful captive breeding program for big cats on the endangered species list. Zoo staff members were kind enough to bring this wonderful white tiger cub out for me and a couple of my artist friends to observe and photograph.*

## PAINT COLORS

Burnt Umber

Cadmium Orange

Cadmium Red Medium

Hooker's Green Permanent

Raw Sienna

Red Oxide

Titanium White

Ultramarine Blue

Yellow Light Hansa

## MIXTURES

warm black

dark green

yellow-green

blue-shadow

pink

buff

blue eye

warm white

light pink

grass highlight

## BRUSHES

Nos. 3, 10 rounds

Nos. 8, 12 brights

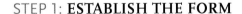

## STEP 1: **ESTABLISH THE FORM**

Sketch the cub lightly onto your panel in pencil, using a kneaded eraser for any corrections or to lighten lines. With diluted Burnt Umber and a no. 10 round, paint the main lines of the cub.

## STEP 2: PAINT THE DARK VALUE COLORS

Mix warm black for the stripes and shadowed areas with Burnt Umber and Ultramarine Blue. Paint with a no. 10 round.

Mix dark green for the background with Hooker's Green Permanent, Burnt Umber, Ultramarine Blue and a bit of Cadmium Orange. Begin to paint with a no. 12 bright, using dabbing strokes. Use a no. 8 bright to paint around the cub's outline.

## STEP 3: PAINT THE MIDDLE VALUE COLORS

Mix yellow-green with a portion of dark green, Titanium White and Yellow Light Hansa. Paint with a no. 12 bright, using a no. 8 bright around the cub's outline. Paint dark green from the bottom of the painting upwards, blending where it meets the yellow-green.

Mix a blue shadow color with Titanium White, Ultramarine Blue and a small amount of Burnt Umber. Paint the shaded areas of the cub with a no. 10 round. Blend where the stripes meet the blue shadow with a separate no. 10 round and warm black, using small parallel strokes that follow the fur pattern. Use the blue shadow color to blend back into the stripes.

Mix pink for the nose, inside the ears and the toes with Titanium White, Cadmium Red Medium and Red Oxide. Paint with a no. 3 round, blending with a separate no. 3 round and warm black.

Mix a buff color for the ears and mane with Titanium White, Raw Sienna and Cadmium Orange. Paint with a no. 10 round, blending where it meets the adjacent color with separate no. 10 rounds and warm black and pink.

## STEP 4: PAINT THE LIGHT VALUE COLORS AND ADD DETAIL

Mix a blue eye color with Titanium White and Ultramarine Blue. Paint with a no. 3 round. Define the pupils with the warm black and blend where it meets the blue with a separate no. 3 round.

Mix warm white for the coat with Titanium White and a touch of Yellow Light Hansa. Paint with a no. 10 round. Use a no. 10 round for the blue shadow and a no. 3 round for warm black. Reinforce the stripes as needed and add small details to the fur with warm black.

Use buff to blend the shadow under the mouth into the white chin and the shadows on the legs. Tone down the edges of the stripes with small strokes of the blue shadow color, then re-establish and blend with warm black. Paint detail in the white fur with small strokes of the blue shadow and a no. 3 round, blending with warm white.

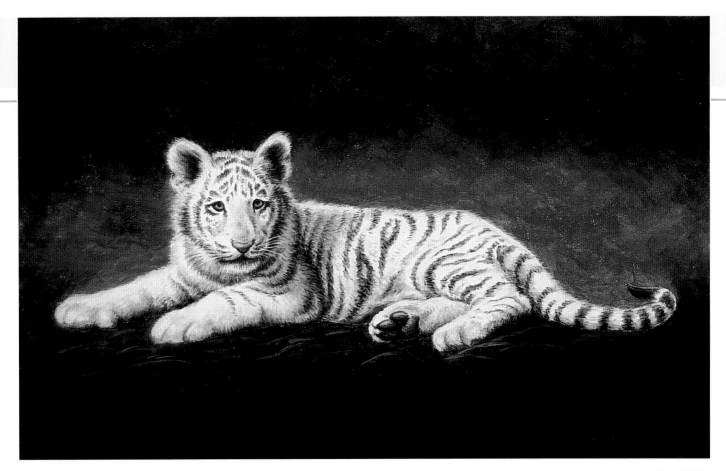

## STEP 5: **PAINT THE FINISHING DETAILS**

Paint the whiskers with Titanium White and a no. 3 round. The paint should be slightly thinned with water, but not soupy. Paint thin, flowing, slightly curved strokes. Tone down any whiskers that look too thick or prominent with the adjacent color.

Mix a light pink highlight color for the nose and toes with a portion of pink, Titanium White and a touch of Yellow Light Hansa. Paint the highlights with a no. 3 round, blending with the adjacent color. Reinforce the shape of the nose with warm black, then paint highlights on the nose, blending where it meets the adjacent color. Paint a little buff above the nose, blending up into the white.

With yellow-green, use a no. 10 round to paint blades of grass with quick, light strokes. Mix a grass highlight color with a portion of yellow-green, Titanium White and Yellow Light Hansa. Paint a few highlighted blades with a no. 10 round. Tone down as needed with dark green.

Tone down the small, triangular-shaped dark shadows of the ear folds with a no. 3 round and buff, using small, light-pressured strokes. Re-establish with warm black as needed, blending with buff.

**Tiger Child**
Acrylic on Gessobord
7½" × 12" (19cm × 30cm)

**TIP**

Whether painting from photographs or from life, as an artist you are continually choosing to emphasize or de-emphasize elements in the reference material. This is called using your artistic license.

**TIP**

Make the cub look fuzzy by painting small strokes with warm white and a no. 3 round from his outline against the background. Paint longer strokes out from the edges of the ears and mane.

# Zebra Foal

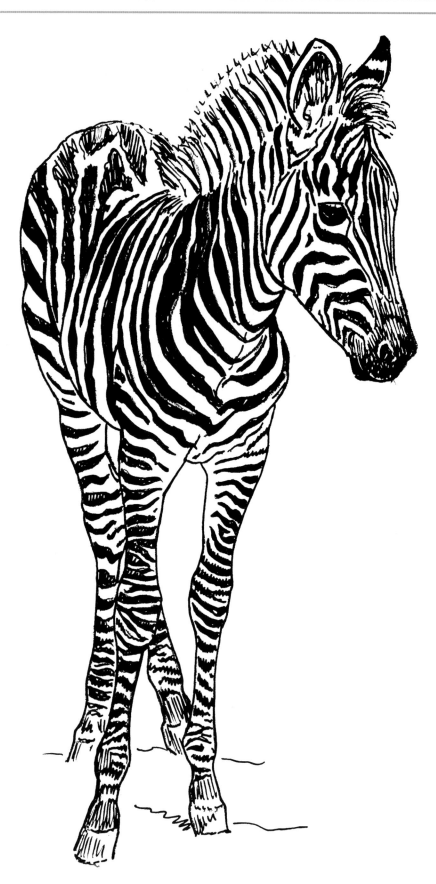

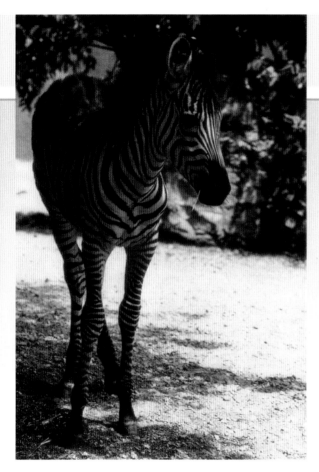

Burnt
Sienna

warm black

Burnt
Umber

red-brown

Cadmium
Orange

warm cream

Hooker's
Green
Permanent

wheaten

Naples
Yellow

blue sky

Raw Sienna

light blue sky

Red Oxide

gray hoof

Titanium
White

hoof highlight

Ultramarine
Blue

light cream

Yellow Light
Hansa

blue shadow

dark red-brown

tree branch
color

**BRUSHES**

Nos. 3, 10
rounds

Nos. 6, 8, 12
brights

green tree

light green
highlight

## REFERENCE

*This beautiful zebra foal was
born at the Cincinnati Zoo.
As I sketched and photographed
the foal, I was struck by the
interesting design its stripes
created.*

## STEP 1: **ESTABLISH THE FORM**

Lightly draw the zebra foal onto your
panel in pencil, using a kneaded eraser
to make corrections or lighten lines. With
a no. 10 round and diluted Burnt Umber,
paint the stripes and other dark areas.

## STEP 2: **PAINT THE DARK VALUE COLORS**

Mix warm black with Burnt Umber and Ultramarine Blue. Paint the stripes with a no. 10 round, making sure they follow the foal's contours. For good, dark coverage, add a second coat when dry. For the narrower stripes and smaller details, use a no. 3 round. Paint the stripes with smooth strokes. Use small, chopping strokes to paint the fuzzy hair on the foal's back and rump. Paint the dark parts of the ears, mane, muzzle, tail and lower legs.

Mix red-brown with Burnt Umber, Raw Sienna and a touch of Red Oxide. Paint the eye with a no. 3 round. Paint the shadows on the ground with a no. 10 round using choppy strokes.

## STEP 3: **PAINT THE MIDDLE VALUE COLORS**

Mix a warm cream for the shadowed areas of the coat with Titanium White, Raw Sienna, Burnt Sienna, and Cadmium Orange. Paint in between the black stripes with a no. 10 round.

Mix a wheaten color for the ground with Titanium White, Raw Sienna and Yellow Light Hansa. Paint dabbing strokes with a no. 8 bright.

Mix a blue sky color with Ultramarine Blue, Titanium White and a touch of Naples Yellow. Mix a lighter blue by adding more Titanium White to a portion of the blue sky color. Paint the blue sky color with dabbing strokes using a no. 12 bright; start at the top of the painting. With a separate no. 12 bright and the lighter blue, paint from the horizon upwards, blending with the blue sky color. Use a no. 10 round to paint around the foals' outline. Blend where the horizon meets the sky with separate brushes for light blue and wheaten.

Mix the grayish hoof color with Titanium White, Ultramarine Blue and Burnt Umber. Paint with a no. 10 round, blending where it meets the shadowed parts of the hooves with a no. 3 round and warm black. Mix a hoof highlight color with a small portion of the gray hoof color and Titanium White. Paint with a no. 3 round.

## STEP 4: PAINT THE LIGHT VALUE COLORS AND THE FINISHING DETAILS

Mix a lighter cream with a portion of warm cream and Titanium White. Paint the lighter areas of the zebra with a no. 10 round, blending into the warm cream.

Paint highlights around the nostril with a no. 3 round and warm cream, blending with the warm black. With warm black and a no. 10 round, re-establish and refine the stripes. Use a no. 3 round for the narrower stripes.

Using a no. 3 round, paint a highlight in the eye with a small arc of Titanium White. With a no. 3 round, paint the eyelashes and the lower eyelid with a bit of blue sky color, using small, parallel strokes. Paint the bar-shaped pupil with warm black.

Mix a blue shadow color for the ground with Titanium White, Ultramarine Blue, Burnt Umber and a touch of Cadmium Orange. Paint with a no. 8 bright, forming parallel, dabbing strokes. Use a no. 10 round to paint between the legs.

Mix a darker red-brown for the foal's shadow on the ground with red-brown and warm black. Paint with the dry-brush technique and a no. 10 round. Use a no. 8 bright to blend into the blue shadow color. Add detail to the wheaten ground with a no. 10 round and a small amount of dark red-brown, blending with the wheaten.

Mix a tree branch color with Burnt Umber, Ultramarine Blue and Titanium White. Paint the branches

**Little Striped One**
Acrylic on Gessobord
12" × 9" (30cm × 23cm)

thinly with a no. 10 round. Mix a green tree color with Hooker's Green Permanent, Burnt Umber, Titanium White and a bit of Cadmium Orange. Use a no. 6 bright to paint the foliage with dabbing strokes.

Paint a very thin glaze of diluted Burnt Umber over the shaded parts of the foal with a no. 6 bright, using a very small amount of the glaze. Re-establish the highlights as needed with the lighter cream and a no. 10 round.

Add small stripes to the lower left hind leg with a no. 3 round and warm cream. When dry, glaze with diluted Burnt Umber. Paint a few light strokes of the blue shadow color on the tail with a no. 3 round, blending with warm black.

Add highlights to the head and chest with Titanium White and a no. 3 round. Re-establish and darken the black stripes as needed.

Mix a light green highlight color for the tree with a portion of the green tree color, Titanium White and Yellow Light Hansa. Paint with a no. 6 bright, using a small amount of paint and light, dabbing strokes.

# RING-TAILED LEMUR BABY

### REFERENCE

*I met this baby ring-tailed lemur at the World Wildlife Exhibition in Gatlinburg, Tennessee, where I was showing my artwork. He was very cute, with large eyes, a bushy tail and humanlike hands. The high point was when the baby lemur sat on my shoulder!*

Burnt
Sienna

warm black

Burnt
Umber

dark brown

Cadmium
Orange

reddish brown

Cadmium
Red
Medium

gray

Raw Sienna

light brown

Titanium
White

pink

Ultramarine
Blue

warm gray

Yellow Light
Hansa

yellow fruit

warm white

shadow color

### BRUSHES

Nos. 3, 10
rounds

blue highlight

Nos. 8, 12
brights

light pink

warm tan

rock shadow

whisker color

## STEP 1: **ESTABLISH THE FORM**

Lightly draw the baby lemur onto the panel in pencil, using a kneaded eraser to correct mistakes or lighten lines. With a no. 10 round and diluted Burnt Umber, paint the basic lines and shading.

## STEP 2: **PAINT THE DARK VALUE COLORS**

Mix warm black with Burnt Umber and Ultramarine Blue. Paint the dark rings around the eyes, the pupils, the muzzle, the tail stripes and the shadows between the fingers and toes with a no. 10 round. For good coverage, paint two or three layers, allowing the paint to dry in between layers.

Mix dark brown with Burnt Umber, Burnt Sienna and Ultramarine Blue. Paint the dark shadow between the feet with a no. 10 round.

## STEP 3: **PAINT THE BACKGROUND AND THE MIDDLE VALUE COLORS**

Mix reddish brown for the background with Burnt Sienna, Burnt Umber and Raw Sienna. Using separate no. 12 brights for each color, paint dark brown around the edges and reddish brown around the lemur. Use dabbing strokes, blending where the two colors meet.

Paint the eyes with reddish brown and a no. 3 round, blending the edges of the pupils with a separate brush and warm black.

Mix gray with Titanium White, Ultramarine Blue, Burnt Umber and a small amount of Burnt Sienna. With a no. 10 round, paint the fingers, the forearms, the top of the head and the shadows inside the ears.

Mix light brown for the fur with Titanium White, Raw Sienna and Burnt Sienna. Paint with a no. 8 bright.

Mix pink for the tongue with Cadmium Red Medium, Titanium White, Raw Sienna and Cadmium Orange. Paint with a no. 3 round.

Mix warm gray for the rock with Titanium White, Ultramarine Blue and Burnt Umber. Paint with a no. 12 bright, using a no. 10 round for painting around the contours of the feet and tail.

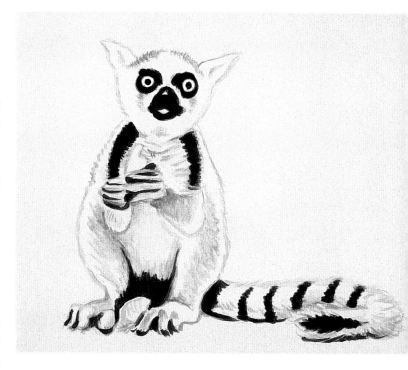

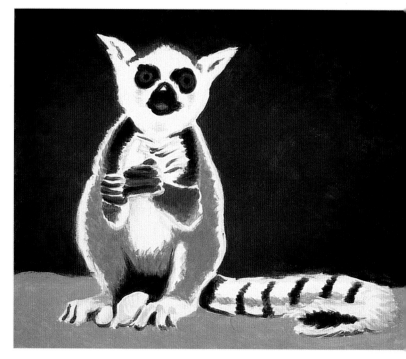

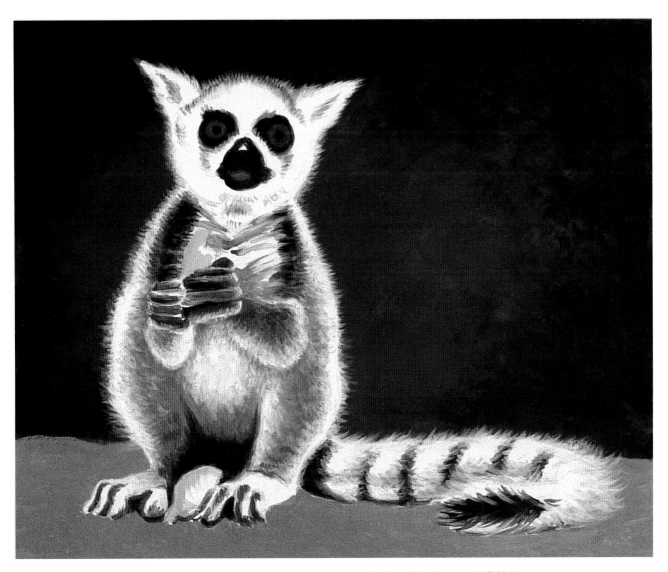

## STEP 4: **PAINT THE LIGHT VALUE COLORS AND BEGIN TO ADD DETAIL**

Mix a yellow color for the fruit with Yellow Light Hansa, Titanium White and Cadmium Orange. Paint with a no. 10 round.

Make a warm white with Titanium White and a touch of Yellow Light Hansa. Paint with a no. 10 round, with strokes following the fur pattern. Blend with a separate brush and the adjacent color.

Use warm gray and a no. 10 round to paint subtle shadows on the chest, head and toes. Paint fuzzy hairs from the outline of the lemur that overlap the background with slightly curving strokes of varying lengths that go in different directions.

Mix a shadow color for the toes and fur with portions of reddish brown, dark brown and light brown. Paint shadows on the toes, then begin to paint shadow detail in the fur.

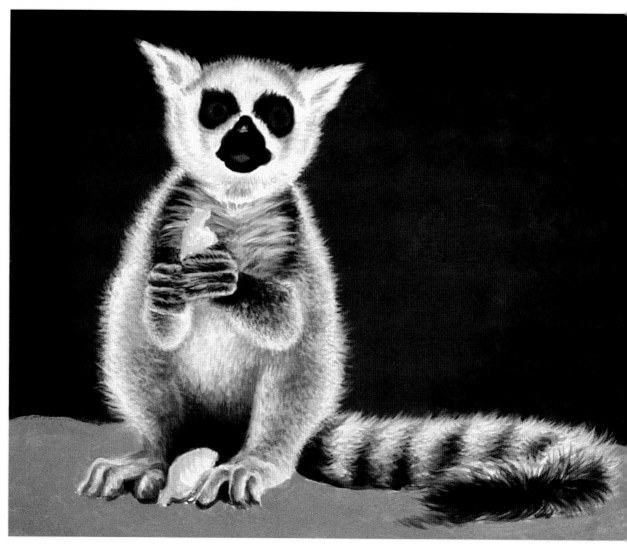

## STEP 5: **ADD MORE DETAIL**

With warm black and a no. 10 round, add detail to the tail with long strokes, and to the fingers with short strokes. Using separate no. 10 rounds for each color, use warm black, light brown and warm white to add detail to the fur with overlapping strokes.

Use the same technique to add detail to the chest with warm gray, warm black and warm white.

With separate no. 3 rounds for warm black and warm white, refine and add detail to the fingers. Paint the feet with warm white and light brown, using warm black for shadows and detail.

Darken and refine the shape of the muzzle and dark eye rings with warm black and a no. 10 round. Add fur detail to the head with light brown and warm white.

**TIP**

Transfer portions of the colors to a dry palette. This will give the paint a less liquid consistency and aid in painting detail. If the paints begin to dry, spray lightly with water.

**TIP**

Painting with thicker paint will make the highlight pop out. This technique is called *impasto*.

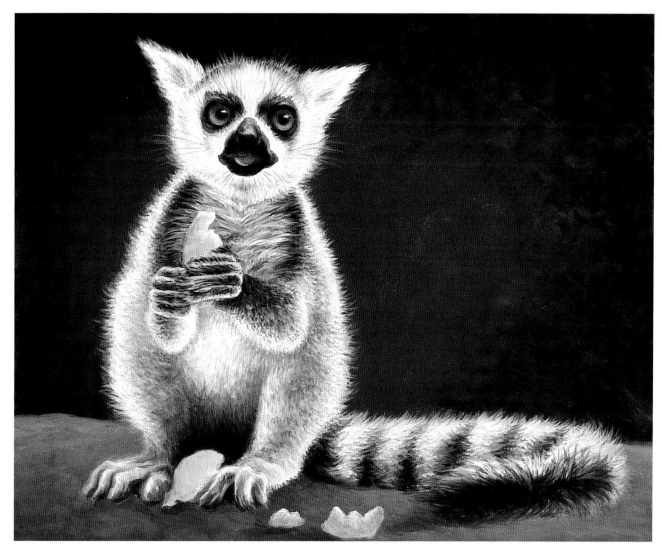

## STEP 6: **PAINT THE FINISHING DETAILS**

**Afternoon Snack**
Acrylic on Gessobord
9" × 12"
(23cm × 30cm)

Mix a blue highlight color for the nose with a warm white mixed with a touch of Ultramarine Blue. Mix a pinkish highlight color for the tongue with a bit of pink and warm white. Paint both with separate no. 3 rounds.

Mix a warm tan for the eyes with Titanium White, Raw Sienna and a touch of Cadmium Orange. Paint with a no. 3 round, blending with reddish brown and a separate brush. When dry, paint a very thin glaze of Cadmium Orange and water over the warm tan. Paint highlights in the eyes with small arcs of Titanium White using a no. 3 round.

Paint eyelid detail in the black eye rings with the blue highlight color and a no. 3 round. Blend with warm black.

Paint a glaze of Cadmium Orange and water over the yellow fruit. With a no. 3 round, add detail to the head with light brown, blending with a separate brush and warm white. Add detail to the feet using no. 3 rounds with light brown, warm white and warm black. Add highlights to the fruit between the paws with warm white.

Mix a rock shadow color with a portion of reddish brown, light brown and dark brown, and paint with a no. 8 bright from the bottom on up. When dry, paint a couple more pieces of fruit near lemur's feet.

Paint cast shadows from the tail and fruit on the rock with some dark brown mixed with a bit of the rock shadow color. Mix a whisker color with a bit of gray and warm gray. Use a no. 3 round and a small amount of paint to make feathery, slightly curving strokes from the eyebrows, cheeks and chin.

Exotic Animals    105

# PART FOUR

# Birds

Birds are found everywhere. Many species have adapted to city life, while others can be viewed and photographed in pet shops, zoos, parks and farms, and, of course, at bird feeders. When photographing birds, you need to be quick—birds seldom hold a pose and take off in an instant! One of the main considerations when painting birds is to get the feather pattern right. Otherwise, they are fairly easy to draw, with their rounded, simple shapes. I enjoy painting birds because they are such beautiful creatures.

There is a great deal of variety in the world of birds, but all are enjoyable to paint, from the small brown sparrow to the showy bird of paradise. In this chapter, I've chosen birds that are both colorful and unusual.

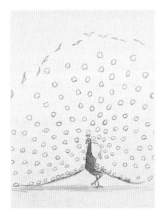 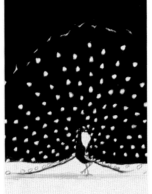  

**Fan Dancer**
Acrylic on Gessobord
10" × 8" (25cm × 20cm)

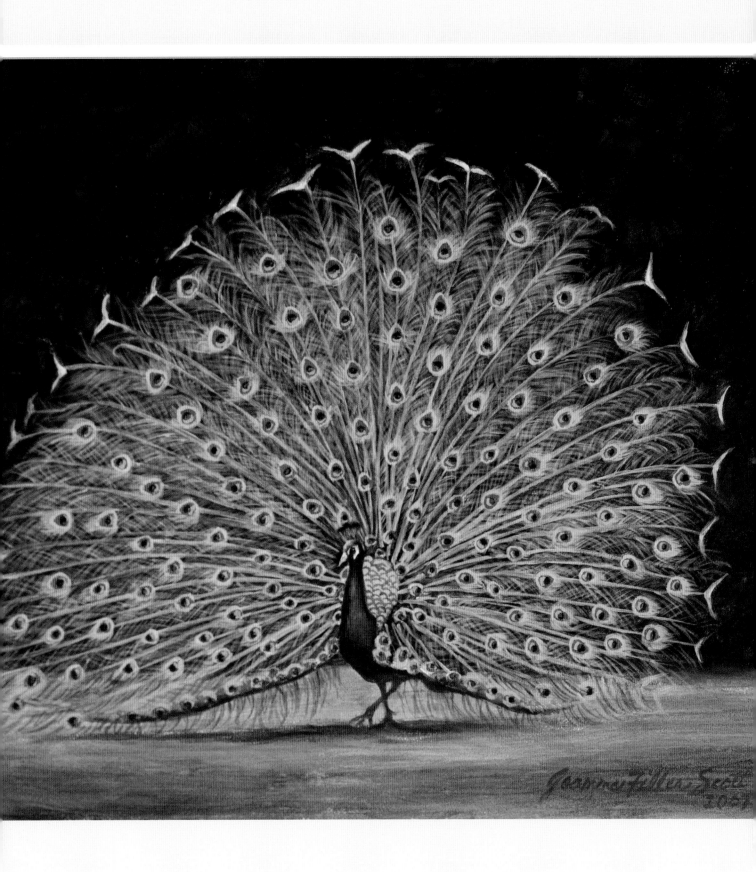

# PEACOCK

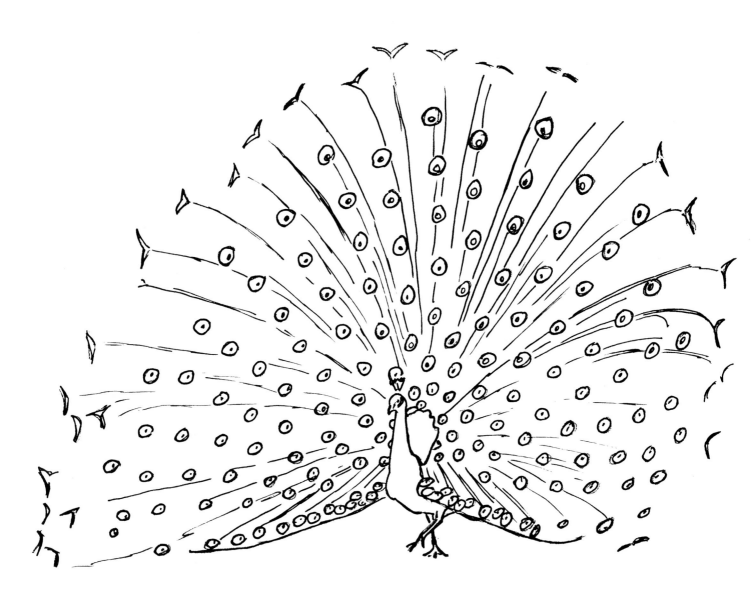

## REFERENCE

*The Indian Blue peacock has brilliant, iridescent blue-green plumage. The tail, also called the train, has a series of feathers called eyes, which are seen when the tail is fanned. This magnificent peacock lives at the Primate Rescue Center in Jessamine County, Kentucky. The peafowl roam freely around outdoor enclosures for monkeys and apes.*

**PAINT COLORS**    **MIXTURES**

Burnt Umber     warm black

Cadmium Orange     bright blue

Hooker's Green Permanent     dark green

Naples Yellow     dark brown

Raw Sienna     shadow color

Red Oxide     golden tan

Titanium White     light green

Ultramarine Blue     light tan

     blue highlight

Yellow Light Hansa     brick red

     medium blue

     medium green

### BRUSHES

Nos. 3, 10 rounds
Nos. 6, 12 brights

## STEP 1: **ESTABLISH THE FORM**

Lightly sketch the peacock onto the panel in pencil, using a kneaded eraser for corrections or to lighten lines. With diluted Burnt Umber and a no. 10 round, paint the main lines of the peacock.

## STEP 2: PAINT THE BACKGROUND AND BODY COLORS

Mix warm black with Ultramarine Blue and Burnt Umber. Paint the dark shadows on the bird's body and the dark lines on the underside of the tail with a no. 10 round. Mix bright blue for the bird's body with Ultramarine Blue and Titanium White. Paint with a no. 3 round, blending with the shadowed areas.

Mix dark green for the background with Hooker's Green Permanent, Burnt Umber and Ultramarine Blue. Paint dabbing strokes with a no. 12 bright, switching to a no. 6 bright to paint around the feather patterns. Use a no. 10 round to paint around the peacock's body. After the first layer of dark green has dried, strengthen it with a second coat.

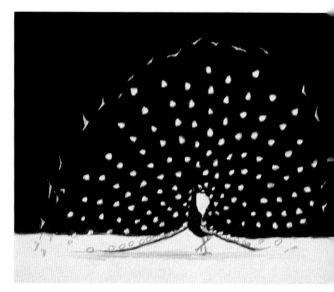

## STEP 3: PAINT THE FOREGROUND AND FEATHER PATTERNS

Mix a dark brown for the bird's lower body, legs and feet with Burnt Umber, Ultramarine Blue and Raw Sienna. Paint with a no. 3 round.

Make a shadow color for the bird's shadow on the ground with Burnt Umber and Raw Sienna. Paint horizontal strokes with a no. 10 round.

Create a golden tan for the ground with Titanium White, Raw Sienna and Naples Yellow. Paint smooth, horizontal strokes with a no. 12 bright; switch to a no. 6 bright to paint around the bird. Blend where the shadow and dark green meet the golden tan, using separate no. 6 rounds for each color.

Paint the dark line at the underside of the tail with dark green and a no. 10 round. Mix Hooker's Green Permanent, Yellow Light Hansa, Cadmium Orange and Titanium White to create light green for the mass of feathers behind the neck. Paint with a no. 10 round. With the same color and a no. 3 round, paint the feather eyes.

Re-establish the legs and feet with dark brown and a no. 3 round. Darken the bird's shadow on the ground with a few horizontal strokes of dark brown.

Make a light tan for the feather shafts with a portion of golden tan and Titanium White. Paint the shafts with a no. 3 round, using long, thin, slightly curving strokes; use just enough water to make the paint flow. Use the same color to paint the beak. More than one coat is needed for good coverage. Make any corrections, such as shafts that come out too thick or uneven, with dark green.

Mix a highlight color for the bird's body with some bright blue and Titanium White. Paint with a no. 3 round, blending with the adjacent color. Re-establish the white marking on the head with Titanium White. Add a tiny dot of Titanium White to the eye for the highlight.

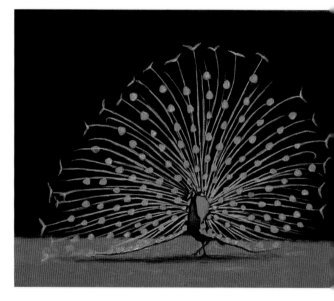

**TIP**

It's OK to paint over the feather eyes when painting the long strokes for the shafts. This makes the strokes more smooth and continuous. The feather eyes can be re-established later.

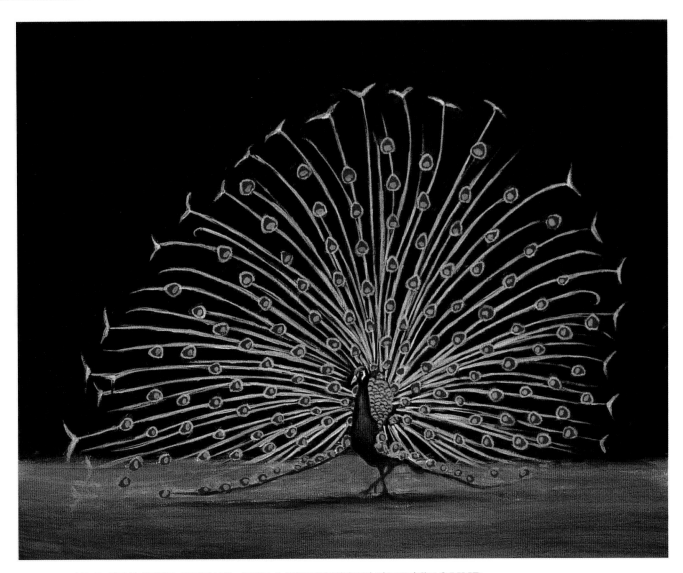

## STEP 4: **ADD FEATHER DETAIL AND MODIFY THE FOREGROUND**

Darken the golden tan foreground with a glaze of diluted Burnt Umber. Paint horizontal strokes with a no. 12 bright. When dry, create shadows at the lower part of the foreground and darken the bird's shadow on the ground with a glaze of Ultramarine Blue and water.

Make a brick red color for the feather eyes with Red Oxide, Titanium White and Naples Yellow. Paint the inside of the feather eyes with a no. 3 round, leaving a border of green. Re-establish the green borders as needed.

Create medium blue for the feather eyes with Ultramarine Blue and Titanium White. Paint small spots inside the brick red areas at the lower part of the feather eyes with a no. 3 round.

With dark green and a no. 3 round, sharpen and define the V-shaped feathers at the edges of the tail.

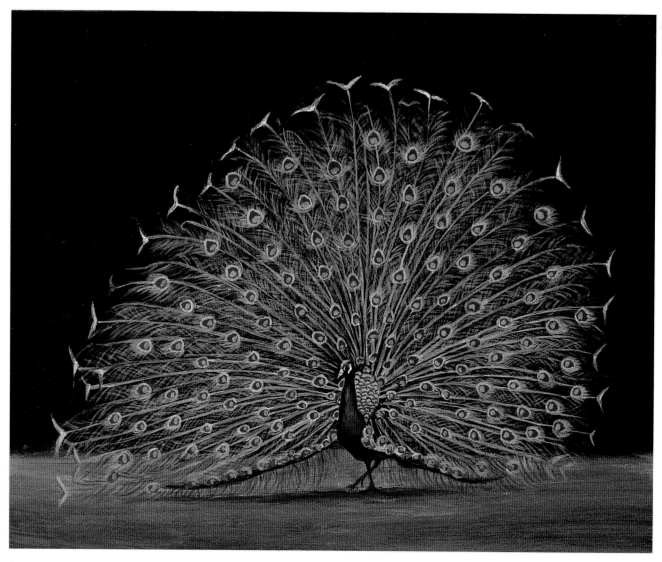

## STEP 5: **PAINT MORE FEATHER DETAIL**

With a glaze of diluted dark green, use a no. 10 round to slightly darken the feather shafts. Using light green and a no. 3 round, paint a fringe from the tip of each feather eye with small strokes. Use the same color and brush and a small amount of paint to create the feather patterns from each shaft with thin, parallel strokes. The overlapping lines will create a crisscross pattern.

With a no. 3 round, paint a thin glaze of Yellow Light Hansa and water over the mass of feathers behind the neck. Reinforce the dark lines on the underside of the tail with a no. 3 round and dark green. Make medium green with some dark green, light green and Yellow Light Hansa. Paint along the underside of the tail with a no. 3 round, blending where it meets the dark green with a separate brush and dark green.

Paint the feather detail for the feathers overlapping the golden tan with dark green and a no. 3 round, toning down as needed with light green. Paint a thin fringe of feathers hanging down from the underside of the tail with dark green and a no. 3 round, using a small amount of diluted paint.

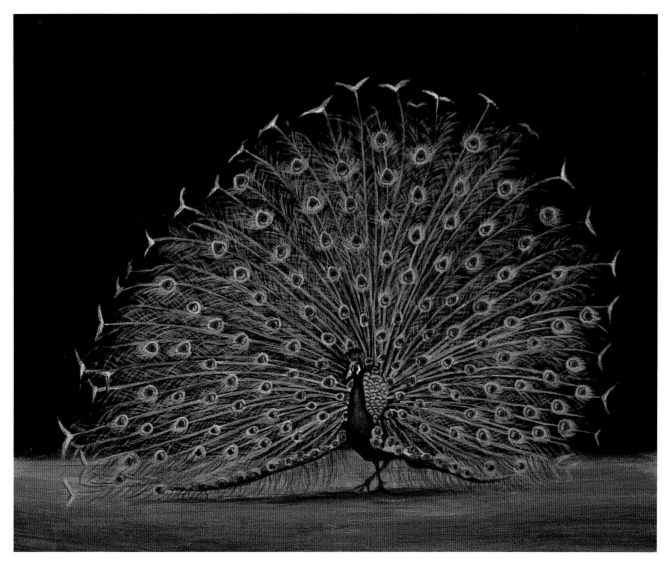

## STEP 6: **PAINT THE FINISHING DETAILS**

Use bright blue and a no. 3 round to paint the rounded dark spots on the feather eyes. When dry, reinforce as needed with a second coat. Paint the crest of feathers above the head with bright blue.

Use light green to paint fringes from any of the feather eyes you may have missed in the previous step.

**Fan Dancer**
Acrylic on Gessobord
8" × 10" (20cm × 25cm)

# PARROT

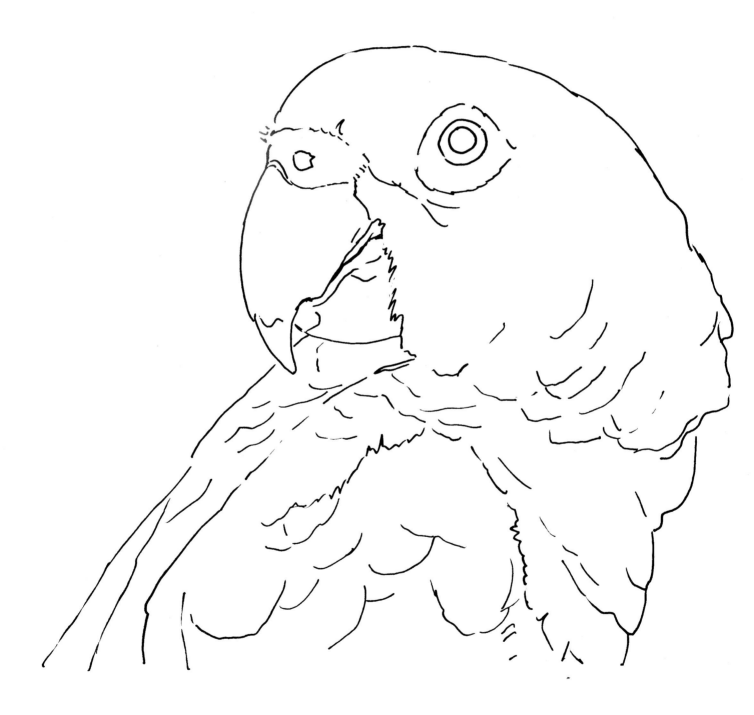

**Painting More Animal Friends**

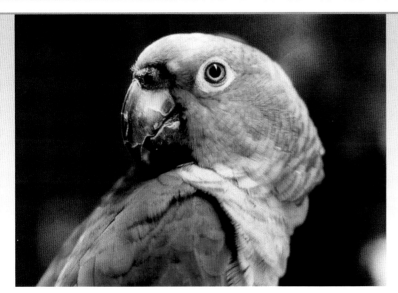

### REFERENCE

*This Yellow-naped Amazon was part of a group of exotic animals shown at the World Wildlife Exposition in Gatlinburg, Tennessee, where I was also exhibiting my wildlife art. I was impressed by this parrot's intelligent eyes, as well as its beautiful feathers.*

 Burnt Umber

 warm black

Cadmium Orange

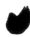 cool red

Hooker's Green Permanent

 light red

Raw Sienna

 green feather

Red Oxide

 gray

Titanium White

 blue

Ultramarine Blue

 dark orange

Yellow Light Hansa

 light green

 yellow

 bright yellow

### BRUSHES

Nos. 3, 10 rounds
Nos. 8, 10 brights

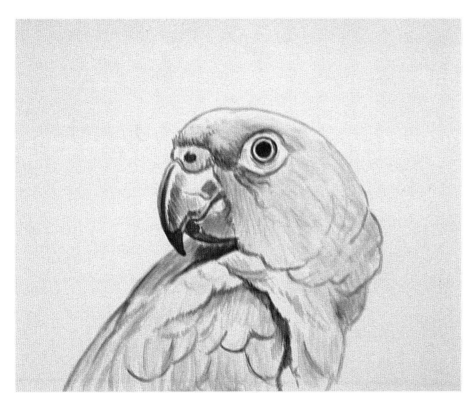

## STEP 1: ESTABLISH THE FORM

Lightly sketch the parrot onto your panel in pencil, using a kneaded eraser to lighten lines or correct mistakes. With a no. 10 round and diluted Burnt Umber, paint the basic lines and shading of the parrot.

## STEP 2: **PAINT THE DARK VALUE AND BEGIN THE BACKGROUND**

Mix warm black for the darkest parts of the parrot with Burnt Umber and Ultramarine Blue. Paint with a no. 10 round, switching to a no. 3 round for the dark ring around the eye.

Make a cool red background color with Red Oxide, Burnt Umber and Ultramarine Blue. Then create a lighter red background color using the same colors plus Raw Sienna, Cadmium Orange and Titanium White. Paint with separate no. 10 brights, starting with the darker color at the lower part of the painting. Blend up into the lighter red with dabbing strokes.

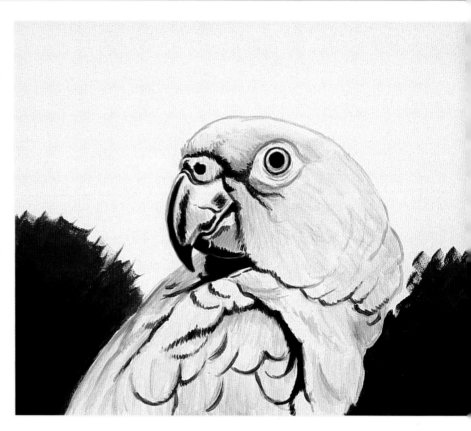

## STEP 3: **FINISH THE BACKGROUND AND PAINT THE MIDDLE VALUE COLORS**

Mix a green feather color with Hooker's Green Permanent, Cadmium Orange, Titanium White and Yellow Light Hansa. Paint with a no. 8 bright, using strokes that follow the feather pattern. Re-establish the main shadow lines in the feathers with warm black and a no. 10 round.

Mix gray with Titanium White, Burnt Umber, and Ultramarine Blue. Paint the beak and the cere (the membrane at the base of the beak) with a no. 10 round. Mix blue for the ring around the eye with Titanium White, Ultramarine Blue and a small amount of Burnt Umber. Paint with a no. 10 round. Mix dark orange for the eye with Red Oxide, Cadmium Orange and a bit of Burnt Umber. Use a no. 3 round to paint around the outer edge of the eye.

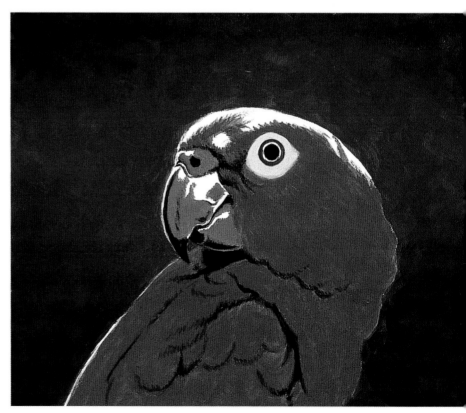

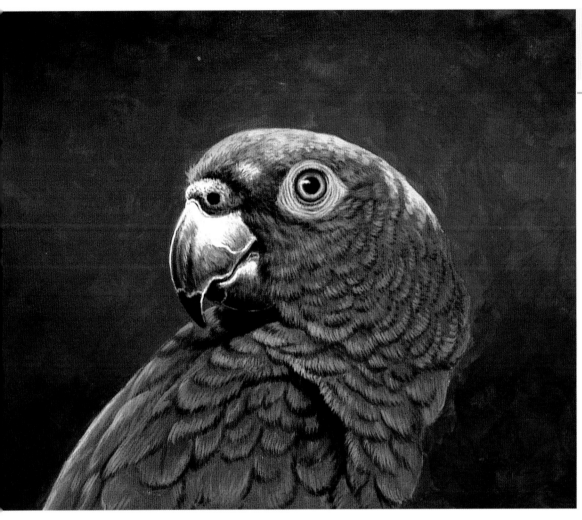

**A Wise and Intelligent Bird**
Acrylic on Gessobord
8" × 10" (20cm × 25cm)

## STEP 4: **PAINT THE LIGHT VALUE COLORS AND THE FINISHING DETAILS**

Make light green for the feather highlights with a portion of the green feather color, Titanium White and Yellow Light Hansa. With a no. 10 round, paint the highlighted area at the top of the head and along the back.

Create warm white with Titanium White and a touch of Yellow Light Hansa. Paint highlights on the back with a no. 10 round, using separate no. 10 rounds for gray and warm black to blend. Use no. 3 rounds for the finer details. Paint the cere with the same colors, using small, dabbing strokes to show texture.

Make a yellow for the ring of color around the eye next to the pupil with Titanium White, Yellow Light Hansa and a touch of Cadmium Orange. Paint with a no. 3 round, blending with dark orange and a separate no. 3 round. Re-establish the dark outer ring around the eye with warm black and a no. 3 round.

Mix Yellow Light Hansa and a bit of Titanium White to create bright yellow for the scattered yellow feathers on the head. Paint with a no. 10 round.

With warm black and a no. 10 round, begin to paint the shadows that define the edges of the feathers with light, parallel strokes. Blend with a separate brush and the green feather color, using small strokes. Paint the highlighted area at the top of the head in the same way, using the green feather color for the shadows, blending with small strokes of light green.

With no. 3 rounds, use warm black to lightly paint detail in the blue area around the eye, blending with blue. Paint a highlight in the eye with Titanium White and a no. 3 round, blending the edges with warm black and a separate brush.

Continue to paint the feather shadow detail with warm black. Paint feather highlights with light green, blending with the green feather color.

# SCARLET IBIS

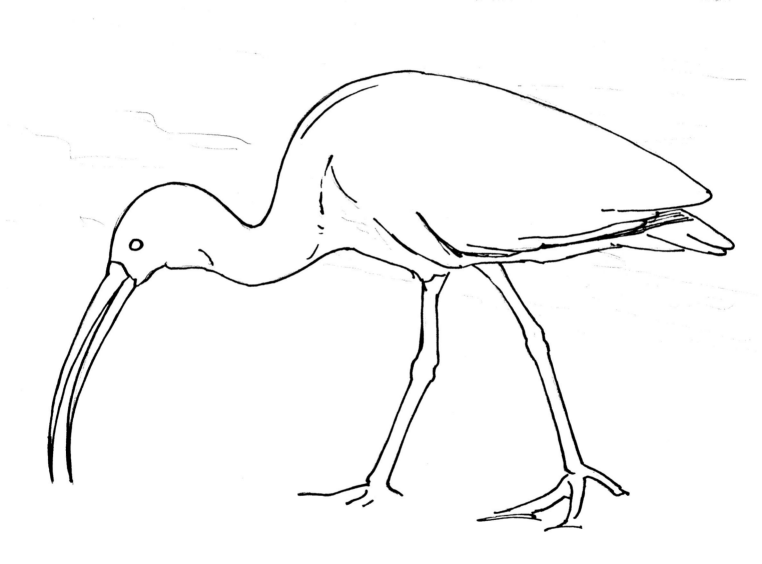

**Painting More Animal Friends**

Burnt
Umber

dark reddish
brown

Cadmium
Orange

warm black

Cadmium
Red
Medium

dark slate gray

Raw Sienna

red feather

Titanium
White

pink

Ultramarine
Blue

sand

Yellow Light
Hansa

salmon pink

blue shadow

light brown

## BRUSHES

Nos. 3, 10
rounds

Nos. 4, 8, 12
brights

## REFERENCE

*The scarlet ibis is a
beautiful bird. Its intense
red color almost seems
unreal. I saw a flock
of these birds at the
Louisville Zoo. The late
afternoon light enhances
the color of their red
feathers and pink legs.*

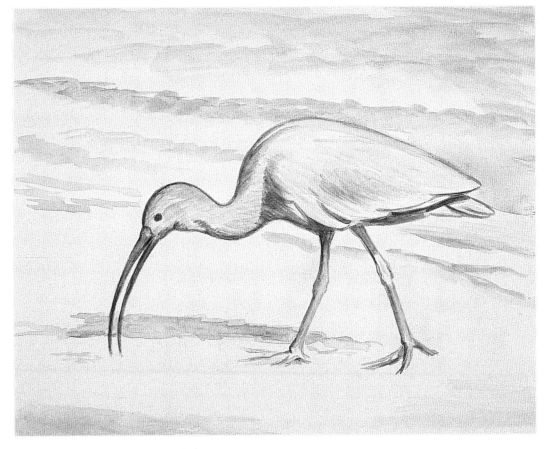

## STEP 1: **ESTABLISH THE FORM**

Draw the bird lightly onto your panel in pencil, using a kneaded eraser to make corrections or lighten
lines. With a no. 10 round and diluted Burnt Umber, paint the basic lines and shading.

## STEP 2: **PAINT THE DARK VALUE COLORS**

Create dark reddish brown for the shadows on the bird's body with Burnt Umber, Ultramarine Blue and Cadmium Red Medium. Paint with a no. 10 round.

Make warm black for the beak and eye with Burnt Umber and Ultramarine Blue. Paint with a no. 10 round.

Mix a dark slate gray for the ground shadows with Burnt Umber, Ultramarine Blue and a tiny amount of Titanium White. Use a no. 8 bright to paint long, smooth strokes. You will need more than one coat to cover.

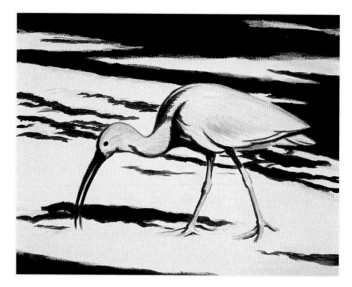

## STEP 3: **PAINT THE MIDDLE VALUE COLORS**

Create a red feather color with Cadmium Red Medium, Cadmium Orange and a touch of Burnt Umber. Paint with a no. 10 round, creating smooth strokes that follow the bird's contours. For broader areas, use a no. 8 bright. Make pink for the legs and feet with a portion of the red feather color and Titanium White. Paint with a no. 10 round.

Create a sand color with Titanium White and a bit of Raw Sienna. Paint smooth strokes with a no. 10 bright; use a no. 10 round to paint around the bird's outline.

## STEP 4: **BLEND, ADD DETAIL AND HIGHLIGHTS**

Reinforce and adjust the shape of the eyes as needed with warm black and a no. 3 round. Paint a tiny highlight within the top of the eye with Titanium White and a no. 3 round.

With two no. 10 rounds, one for the red feather color and one for dark reddish brown, blend where the two colors meet, creating a smooth transition.

With a no. 10 bright, paint a thin glaze of diluted dark slate gray over the sand-colored areas behind the bird. When dry, paint a thin glaze of diluted Ultramarine Blue over this area.

Using no. 10 rounds, add dark detail to the feathers with dark reddish brown, using light strokes and blending with the red feather color. Paint a thin glaze of diluted red feather color over the legs and feet.

Create a salmon pink for the feather highlights with Titanium White, Cadmium Red Medium, Cadmium Orange and Yellow Light Hansa. Paint the highlights lightly with a no. 10 round.

Use a no. 10 bright to warm up the foreground sand with a thin glaze of diluted Raw Sienna.

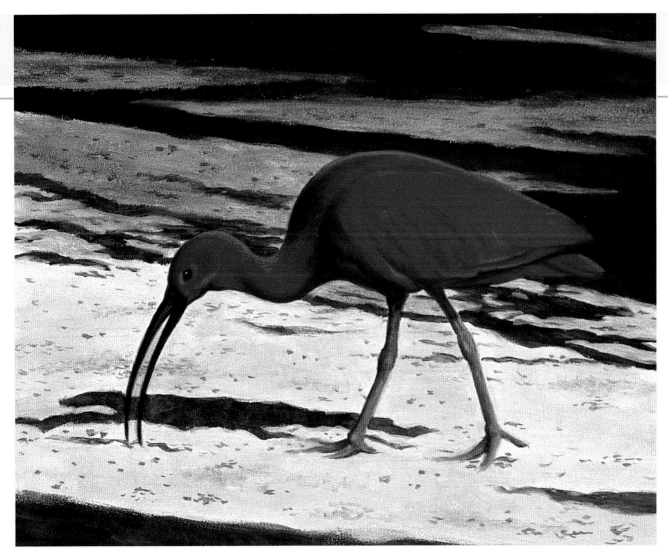

## STEP 5: **PAINT THE FINISHING DETAILS**

Create a blue shadow color with Ultramarine Blue, Titanium White and a touch of Burnt Umber. Use the dry-brush technique to paint over the dark shadows on the ground with a no. 8 bright so that the original color shows through. Use a no. 12 bright for the broader background shadows.

Make light brown for details in the sand by mixing some of the sand color with dark reddish brown. Paint small, irregularly shaped dots lightly with a small amount of paint and a no. 10 round. Add a few narrow shadow lines in the sand beneath the beak, under the back foot and behind the bird with a no. 10 round and dark slate gray. When dry, drybrush the bluish shadow color over them.

Add a few subtle shadows on the sand with the blue shadow color and a no. 4 bright. Tone down as needed with the sand color.

Paint dark shadows on the ground behind the bird's head and neck with dark slate gray. When dry, drybrush some blue shadow color over them. Sharpen and reinforce the salmon pink highlights on the head, neck, back and tail with a no. 3 round. Blend the edges with a separate brush and the red feather color.

Add small details to the legs and feet with dark reddish brown and a no. 3 round. Add subtle highlights with a no. 3 round and the sand color.

Add highlights to the beak with a no. 3 round and salmon pink, blending with a separate no. 3 round and warm black. Sharpen the lines of the beak with warm black.

**Crimson Forager**
Acrylic on Gessobord
10" × 8" (25cm × 20cm)

**TIP**

For any places where the paint becomes too thick, quickly use your fingertip to smooth it out before the paint dries.

If any of the shadows look too light after dry-brushing the blue shadow color over them, drybrush dark slate gray to darken them again, allowing some of the blue shadow color to show through.

# Hyacinth Macaws

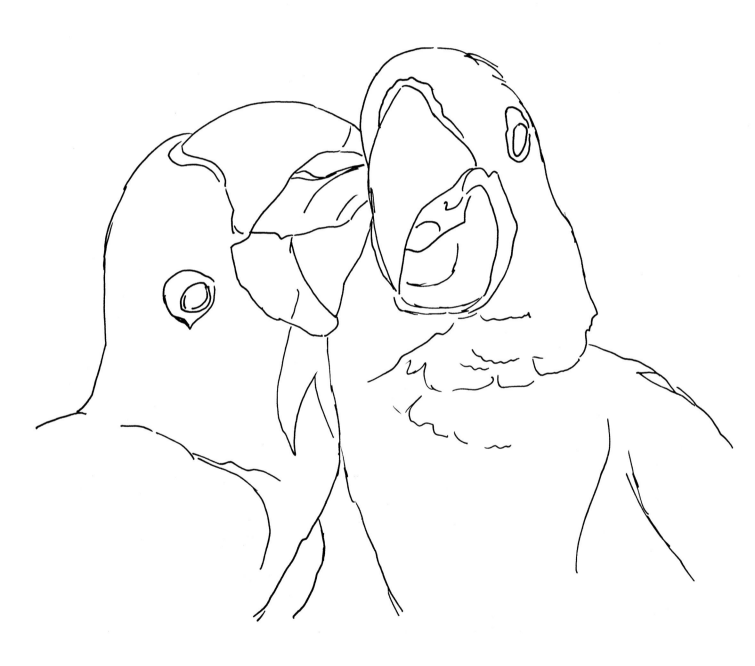

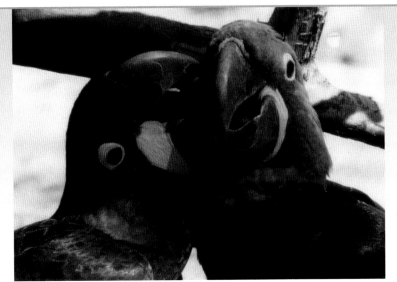

**REFERENCE**

*I observed these hyacinth macaws at the Caldwell Zoo in Tyler, Texas. They were a very loving pair—constantly grooming and nibbling at each other and locking beaks in what looks very much like a kiss.*

Burnt
Sienna

blue-black

Burnt
Umber

blue feather

Cadmium
Orange

yellow-orange

Naples
Yellow

warm gray

Raw Sienna

soft green

Titanium
White

light gray

Ultramarine
Blue

yellow highlight

Yellow Light
Hansa

pale blue

rusty orange

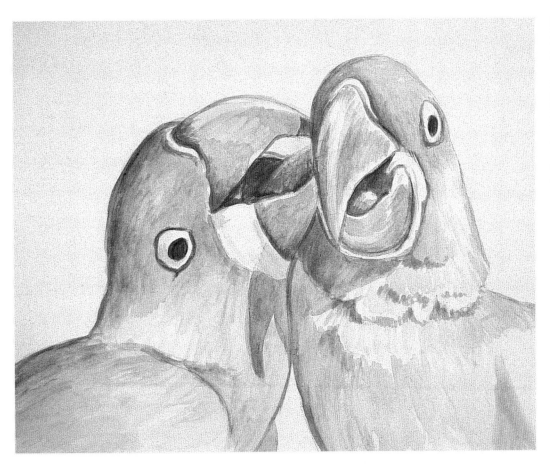

**BRUSHES**

Nos. 3, 10
rounds
No. 10 bright

## STEP 1: **ESTABLISH THE FORM**

Lightly draw the macaws onto the panel in pencil, using a kneaded eraser to make corrections or lighten lines. With a no. 10 round and diluted Burnt Umber, paint the basic lines and shading.

## STEP 2: **PAINT THE DARK VALUE COLORS**

Create blue-black with Burnt Umber and Ultramarine Blue. Paint the darkest areas with a no. 10 round.

## STEP 3: **PAINT THE MIDDLE VALUE COLORS**

Make a blue feather color with Ultramarine Blue and small amounts of Titanium White and Burnt Umber. Paint with a no. 10 bright following the contours of the birds. Use a no. 10 round for painting smaller areas. When dry, add another coat.

Create yellow-orange for the shaded areas of the parrots' yellow markings with Yellow Light Hansa, Cadmium Orange and Raw Sienna. Paint with a no. 10 round.

Make warm gray for the beaks and tongue with Titanium White, Burnt Umber, Ultramarine Blue and Burnt Sienna. Paint with smooth strokes using a no. 10 round.

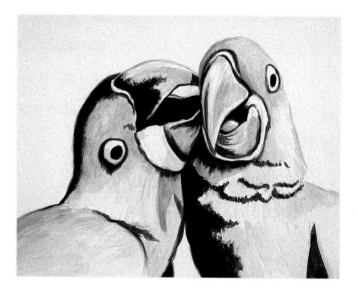

## STEP 4: **PAINT THE LIGHT VALUE COLORS AND BACKGROUND AND BEGIN TO ADD DETAIL**

Mix a soft green for the background with Naples Yellow, Ultramarine Blue and Titanium White. Paint with dabbing strokes using a no. 10 bright; use a no. 10 round for around the parrots' outlines.

Mix light gray for beak highlights with a portion of warm gray, Titanium White and a bit of Raw Sienna. Paint with a no. 10 round.

Mix a yellow highlight color for the parrots' markings with a portion of yellow-orange, Titanium White and a small amount of Yellow Light Hansa. Paint with a no. 10 round, blending with a separate brush and yellow-orange.

Begin to add detail to the beaks and feathers with blue-black and a no. 10 round. Paint parallel, light-pressured strokes.

**TIP**

To see the feather pattern more clearly when looking at your reference photo, squint your eyes. This will make the overall pattern stand out.

**Painting More Animal Friends**

## STEP 5: ADD THE FINISHING DETAILS

Mix some of the blue feather color and Titanium White to create a pale blue for the feather highlights. With a no. 10 round, paint lightly with semidry, parallel strokes that follow the feather pattern. If your paint is too soupy, transfer a portion to a dry palette. Tone down as needed with the blue feather color.

Continue to add dark detail to the feathers and beaks with blue-black and a no. 10 round. Indicate the tongue of the parrot on the left with warm gray.

Mix a rusty orange for detail in the yellow areas around the beaks and eyes with a portion of yellow-orange mixed with Burnt Sienna and Cadmium Orange. Paint thin lines with a no. 3 round, blending with a separate no. 3 round and the adjacent color.

Refine the shape of the eyeballs with a no. 3 round and blue-black. With a no. 3 round, paint the lower eyelids with a bit of warm gray mixed with a bit of light gray.

Paint highlights in the eyes with pale blue. Add a little more detail in the shoulder area of the bird on the left with quick, light strokes of pale blue and blue-black.

Mix a beak highlight color with Titanium White and a touch of Yellow Light Hansa. Paint with a no. 3 round, blending the edges with the adjacent colors: warm gray and light gray. Also, add more detail to the beaks with those colors and a no. 3 round.

**Affectionate Pair**
Acrylic on Gessobord
8" × 10" (20cm × 25cm)

**TIP**

To achieve a semidry brush, wipe the brush lightly on a paper towel after dipping it into the paint.

# CONCLUSION

The artist who paints animals has an amazing variety of subjects to choose from. There is always a new and interesting challenge in portraying the individual characteristics of the myriad animals in the world. According to the *World Book Encyclopedia*, scientists estimate that there are as many as fifty million species of animals alive today.

Gathering references can also be challenging, but it's a lot of fun too. Generally, animals won't stay still to be photographed or sketched. You have to learn to be quick to take advantage of a good pose, since it may last only a few seconds. Whenever possible, meeting and interacting with the animals you want to paint is rewarding and can teach you things you will carry back with you to the studio. Your paintings will be better for having seen the animal with your own eyes.

The animal artist should also study landscapes since the setting is such an important part of the painting. If the animal you are painting is from a place you've never been, you can refer to books or videos for background ideas. Apply the same techniques you would use to paint landscapes you know to those that are less familiar.

I hope you have learned a lot and enjoyed painting these animals as much as I did!

**Little Striped One**
Acrylic on Gessobord
12" × 9" (30cm × 23cm)

# INDEX

**A**

Acrylic paint, 12–13
    consistency of, 11, 13, 64–65, 77, 104
Artistic license, 47, 95

**B**

Background, 15, 31, 64
    choice of, 47
    manipulation of, 69, 73
    photographs, 19
    researching, 84
Birds, 106–125
    purple finch, 17
Bison calf, 70–73
Black, for fur, 12, 54, 63
Black bear, 40–43
Blending, with fingertip, 26, 121
Box turtle, 44–49
Branches, 60–61, 99. *See also* Trees
Brushes, 10
Brushstrokes, 14

**C**

Camera equipment, 18
Carbon paper, 11, 13
Chipmunk, 20–21, 36–39
Clouds, 15
Color mixing, 11–12, 91
Columbian ground squirrel, 22–27

**D**

Dabbing, 14
Deer, white-tailed, 32–35
Depth, 25, 31, 64
Dry palette, 31, 35, 104

Drybrush technique, 14, 48, 121
    semi-dry, 125
Duck, 8–9

**E**

Ears, 12, 30–31, 64, 94
Elephant, 3, 82–87
Eraser, 10
Eyes, 31, 87, 91, 94, 116–117

**F**

Feathers. *See* Birds
Found objects, 19
Fox cub, 3, 74–79
Fur, 26, 56, 94

**G**

Gessobord, 10
Giraffe, 88–91
Glazing, 14
Goose, 6
Grass, 12, 15, 26–27, 31, 65, 69, 73, 95

**H**

Highlights, 13, 49, 104
Horse, paint foal, 2, 17, 66–69
Hyacinth macaws, 122–125

**I**

Ibis, scarlet, 118–121
Image size, adjusting, 13
Impasto, 104

**L**

Landscape background, 15, 126

Lemur, ringtailed, 80–81, 100–105
Light, impression of, 25

**M**

Macaws, hyacinth, 122–125
Masonite, 10
Masterson Sta-Wet Palette, 11
Materials, 10–11
Mouth, pink for, 42

**N**

Nose, pink for, 12, 30, 49, 60, 94

**O**

Opossum, 50–51, 58–61

**P**

Paint. *See* Acrylic paint
Paint foal, 2, 17, 66–69
Palette, 11
Palette knife, 11
Parrot, 3, 114–117, 122–125
Peacock, 6, 106–113
Photographing subjects, 17–19, 126
Pink, mixing, 12, 30–31, 42, 49, 60, 64, 94
Plants, 38–39
Portrait background, 15

**R**

Rabbit, cottontail, 7, 18, 28–31
Raccoon, baby, 52–57
References, sources of, 16–19, 126
Rock, 39, 43, 105

**S**

Sand, 120–121
Scarlet ibis, 118–121
Scumbling, 14. *See also* Dry-brush technique
Shadows, 13, 121
Sketching, 19
Sky, 12, 15, 34, 73, 84, 90
Squinting, 63, 76, 124
Squirrel, Columbian ground, 22–27
Subjects, locating, 16–19, 126

**T**

Technique, 14–15
Tiger cub, white, 7, 92–95
Tracing paper, 11, 13
Transferring sketch, 11, 13
Trees, 15, 55, 57, 76. *See also* Branches
Turtle, box, 44–49

**U**

Underpainting, 13

**W**

Wax paper, 11, 35, 46
White, for fur, 12, 55, 61, 77
White-tailed deer, 32–35
Wolf pup, 62–65

**Z**

Zebra foal, 96–99
Zoos, 16, 80

# LOOK FOR THESE GREAT TITLES FROM NORTH LIGHT BOOKS!

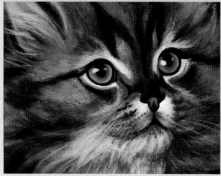

In this fun and informative acrylic book, Lee Hammond applies her popular and simple teaching approach to animals. She covers all the basic materials, techniques and theories and breaks down key animal features such as eyes, mouths, ears, fur and feathers for a wide variety of animals. Includes demonstrations of cats, dogs, horses, cows, rabbits, squirrels, lions, tigers, iguanas, turtles, swans and cockatoos.

ISBN-13: 978-1-58180-912-1
ISBN-10: 1-58180-912-3
PAPERBACK, 128 PAGES, #Z0575

In her first book, *Painting Animal Friends*, Jeanne Filler Scott brings you over 20 different demonstrations of the most popular animals. Learn how to paint cats, dogs, horses, cows, ducks and more, even if you have no fine art training at all! Each demonstration includes reference photos, tips on creating backgrounds, a list of materials and a template line drawing to help get you started right away painting your animal friends.

ISBN-13: 978-1-58180-598-7
ISBN-10: 1-58180-598-5
PAPERBACK, 128 PAGES, #33111

Paint your favorite furry companions with this easy-to-use reference featuring over 40 step-by-step demos for cats, kittens, dogs and puppies! This detailed compilation contains useful painting instruction and insights from over 18 experienced artists working in acrylics, watercolor and oil. Includes demonstrations for both major and mixed-breed cats and dogs in a variety of poses, and detail studies of fur, eyes, paws, tails and noses.

ISBN-13: 978-1-58180-860-5
ISBN-10: 1-58180-869-7
PAPERBACK, 128 PAGES, #Z0125

These books and other fine North Light titles are available at your local fine art retailer, bookstore or online suppliers. Also visit our website at www.artistsnetwork.com.